# KANSAS CITY
# 1940

# KANSAS CITY 1940

### A WATERSHED YEAR

JOHN SIMONSON

Published by The History Press
Charleston, SC 29403
www.historypress.net

Copyright © 2013 by John Simonson
All rights reserved

*Cover images*: Black-and-white images courtesy of Missouri Valley Special Collections, Kansas City Public Library, Kansas City, Missouri. Color image of city hall courtesy of the author.

All images courtesy of the Missouri Valley Special Collections, Kansas City Public Library.

First published 2013

Manufactured in the United States

ISBN 978.1.62619.323.9

Library of Congress CIP data applied for.

*Notice*: The information in this book is true and complete to the best of our knowledge. It is offered without guarantee on the part of the author or The History Press. The author and The History Press disclaim all liability in connection with the use of this book.

All rights reserved. No part of this book may be reproduced or transmitted in any form whatsoever without prior written permission from the publisher except in the case of brief quotations embodied in critical articles and reviews.

*For Curtis Griffin and his comrades.*

# Contents

Acknowledgements 9
Introduction 11

CHAPTER 1. HOME 15

*6 West Sixty-second Street*

CHAPTER 2. FROM BOSS TO GANDIES 19

*5650 Ward Parkway * 1908 Main Street * 414 East Twelfth Street * 1125 Locust Street * 602 East Twelfth Street * 1812 Main Street * 526 Westport Road * 30 West Pershing Road * 100 West Twenty-sixth Street * West Seventeenth and Jarboe Streets * 604 Winchester Avenue * 2401 McGee Street Trafficway * 920 West Twenty-eighth Street * 520 Delaware Street*

CHAPTER 3. FROM VACANT LOT TO MODERN ARCHITECTURE 45

*215 West Thirteenth Street * East Eleventh and Walnut Streets * 1025 McGee Street * 818 Wyandotte Street * 3015 Indiana Avenue * 1617 Park Avenue * 2221 Denver Avenue * 3446 Broadway * 2022 Main Street * 2444 Montgall Avenue * 1115 Armour Boulevard * 3605 Broadway * 104 East Fifty-ninth Street * 1500 Broadway * 419 Main Street * 5447 Forest Avenue*

## Contents

**CHAPTER 4. FROM CLOCKS TO RADIOS**     77

*1016 Baltimore Street * 401 East Twenty-second Street * 1302 Broadway * 2747 Main Street * 915 East Ninth Street * 1912 Main Street * 1204 Baltimore Street * 5120 Rockhill Road * Brush Creek Boulevard and Oak Street * 3616 Belleview Avenue * 1616 Wyoming Street * Twenty-third and Wyoming Streets * 558 Wabash Avenue * 1305 Park Avenue * 1729 Grand Avenue*

**CHAPTER 5. FROM BARBECUE TO BRIMSTONE**     105

*1900 Highland Avenue * 3210 Troost Avenue * Twenty-seventh Street and Troost Avenue * 2600 Tracy Avenue * 1512 Paseo Boulevard * 2128 Brooklyn Avenue * 235 Ward Parkway * 4348 Locust Street * 1247 West Fifty-sixth Street * 3847 Broadway * 1323 Jackson Avenue * 4524 Mill Creek Parkway * 3142 Main Street * Seventy-fifth Street and Prospect Avenue * 5906 Grand Avenue * 7336 Grand Avenue * 301 Van Brunt Boulevard*

**CHAPTER 6. BACK HOME**     137

*203 East Sixty-eighth Street*

| | |
|---|---|
| Epilogue | 141 |
| Suggested Reading | 147 |
| Index | 149 |
| About the Author | 155 |

# Acknowledgements

I am indebted to the Kansas City Public Library. Jeremy Drouin of the Missouri Valley Special Collections provided invaluable assistance in gathering the photos used in this book, and Bill Osment was always on point and a great help at the reference desk.

Thank you to Eugene Morris of the National Archives in College Park, Maryland, for help with documents pertaining to the 1940 tax reassessment.

I'm grateful to Terry Hoyland and his sister, Janet Hoyland, for their memories of Ann Vince. Thanks also to Richard Logan for sending a copy of John Cameron Swayze's liner notes to Capitol Records' release *KC in the '30s*.

As ever, I owe much to my family, past and present.

# Introduction

The story was that the sheets of cardboard with tiny photographs attached—grainy black-and-white images of men holding numbered signs in front of houses, filling stations, storefronts, movie theaters, apartment buildings and public landmarks—were found in a Kansas City dumpster. Clearly they represented some long-forgotten tax assessment. Individual photos had been lost, and a few entire neighborhoods were missing.

For years, the salvaged photos—thousands of images—lived in file cabinets with the Landmarks Commission at city hall, available to anyone looking for an old photograph of a house or commercial building. I first encountered them as many people do, in researching my house's history.

In my photo, a man wore a straw boater, long trousers, a white shirt with rolled sleeves and a loosened necktie. It looked like midday in the dead of summer—bright sun, parched lawns and trees—probably a standard August in Kansas City. He stood on the sidewalk holding a board of numbers, a distraction from the house. Beyond the dumpster tale, the Landmarks Commission knew little about the photos. Curious, I began looking for the backstory.

One chilly morning in late April 1940, Harry McLain aimed a .35mm camera at a house on Kansas City's east side and snapped a picture. McLain

## Introduction

was a fifty-four-year-old former hotel waiter who had fallen on hard times, but thanks to the Work Projects Administration he was working again.

Five years earlier, President Franklin D. Roosevelt had created the WPA (first known as the Works Progress Administration) to, as he said, "put to work three and one-half million employable persons, men and women, who are now on the relief rolls." Nationwide, WPA workers had built thousands of public buildings, bridges, parks, playgrounds, airport runways and miles of roads. They made music and art, presented theater and wrote guidebooks for each state.

Kansas City had about nine thousand WPA workers. They improved roads, widened the Blue River, built sewers and planted shrubs along boulevards. They made linens for hospitals. They taught languages, business and secretarial skills, public speaking and other subjects. They sponsored sports and dance contests. WPA illustrators created an *Index of American Design*. A WPA orchestra performed in parks. There was a WPA nursery school.

The evening after Harry McLain began photographing buildings, a *Kansas City Star* article began, "Actual work on Jackson County's huge reassessment job got under way today when ten crews of WPA cameramen started to make a pictorial record of every house and building in the county."

It was the county's first-ever systematic tax reassessment. Missouri's constitution required taxable property to be uniformly "taxed in proportion to its value," but a study had found a "wide percentage variation in assessment" in Jackson County, "caused by extreme differences in assessment practices." Those practices were sanctioned by the political machine run by Thomas J. Pendergast, which preferred taxing in proportion to a property owner's value to the machine. Now, in April 1940, the machine had been run out of city hall, and Pendergast himself was near the end of his prison term for tax evasion.

Like every two-man photo crew, Harry McLain's carried a board with numbers identifying each parcel and plat. Every night, film was developed, and thumbnail prints were glued onto sheets of cardboard, one sheet for each city block or county plat. Later, other crews measured the thousands of properties. They worked into early fall, and by the end of the year, the project was complete. A report was made, and the photographs were filed away in the county courthouse.

## Introduction

In 2012, the collection was moved to the Missouri Valley Special Collections of the Kansas City Public Library, where it was put in digital form for online access. The photos are of uneven quality. Most are clear, but some are out of focus, poorly framed, washed out or dark. Many may be the only surviving images of long-lost buildings.

The grainy images say something about their gritty times. The men in them say something about what life was like for some citizens. The buildings and the chance pedestrians and passing vehicles say something about the city.

It's a city full of stories, great and small. The stories suggest a mosaic, a multifaceted portrait of a place at a moment between its sinful past and its uncertain future.

# Chapter 1
# Home

## 6 West Sixty-second Street

I pass the house regularly, often on bicycle or on foot, as it's not far from my home. I don't know the current owners, but its first were my great-grandparents, William and Louella Hamilton. They moved in after World War I and stayed more than twenty years. I never knew them in this house—they were living elsewhere by the time I arrived in the 1950s—but I still think of it as their home. Some family stories originate in this house.

It looks much the same today as it does in the photo snapped by a WPA worker in the summer of 1940 for the city's tax reassessment. The photo makes me think of my great-grandfather. He often said—according to one family story—that WPA stood not for Work Projects Administration but for "We Piddle Around," probably because he didn't care for President Roosevelt's New Deal programs and perhaps because he had seen WPA workers loafing. I can imagine his reaction had he looked out his window and realized that the gentlemen with the camera and the numbered sign were being paid with his tax dollars.

The photo was snapped not long after a man with a clipboard had come to the house for the 1940 U.S. Census. The information my great-grandmother gave him showed that William Hamilton—he was "Will" to most—turned sixty-five that year; Louella was two years younger. They shared their home with an adult daughter, Margaret, and a live-in Czechoslovakian maid, Amelia, both forty years old. The household did not include the twenty-six-

# Kansas City 1940

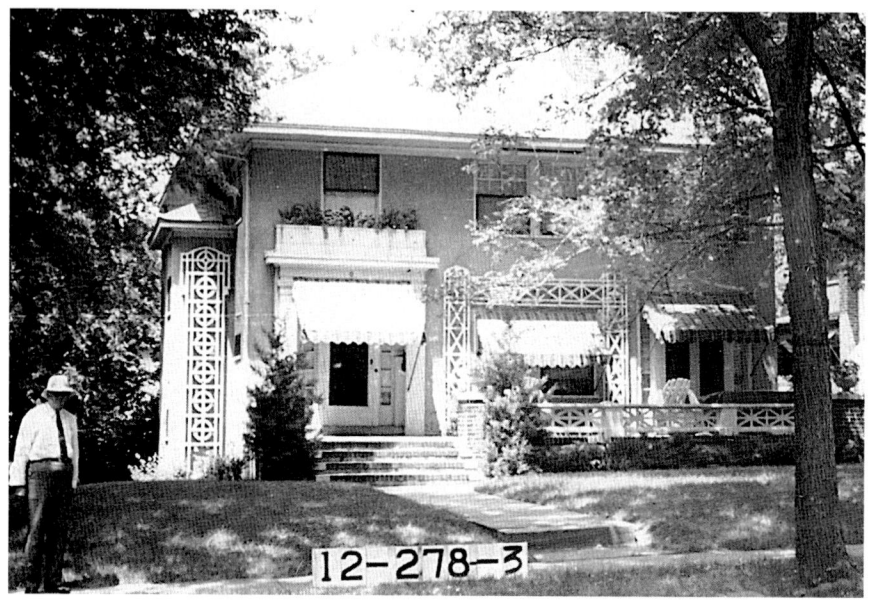

The Hamilton home, 6 West Sixty-second Street.

year-old chauffeur the Hamiltons employed for Louella, who did not drive. He was a Filipino man named Nemecio, whom everyone called "Nasho." Nasho lived in a cheap downtown hotel.

The house had been built in the early 1920s as part of the Morningside neighborhood, an upper-middle-class development of the Fletcher Cowherd Company that benefited from being adjacent to J.C. Nichols's Country Club District and Brookside shops. Morningside residents were business owners, professionals and executives, people like William Deramus, general manager of Kansas City Southern Railway; Ursula Genung, society editor of the *Kansas City Journal*; H. Wheeler Godfrey, vice-president of Barrons Advertising; and Fletcher Cowherd himself, who lived next door to the Hamiltons' older daughter, son-in-law and two granddaughters, ages eleven and sixteen.

Will was college-educated, Republican and a veteran of the wholesale grocery business, beginning as his brother's partner in a small southeast Kansas company, which they relocated to Kansas City in 1911. During the world war, the brothers merged their business with the H.D. Lee Mercantile Company of Salina, Kansas, which then built new headquarters at Twentieth and Wyandotte Streets.

# Home

By 1940, Will was managing Lee's cooperative system of High Grade Food Stores, independent grocers who had joined together to compete against the growing threat of chain supermarkets. His son-in-law also worked at Lee, as did daughter Margaret.

Louella was Victorian in spirit—born, raised, educated and married here; she was a small-town Kansas mother before the end of the nineteenth century and a housewife who managed a proper home. She took her granddaughters downtown on the Country Club streetcar to shop, lunch and see a movie. She saved newspaper clippings by fastening them together with straight pins. She marked passages in her Christian Science publications, such as, "The less said or thought of sin, sickness or death, the better for mankind morally and physically."

The Hamiltons enjoyed traveling. Margaret had toured Central America by steamship. Her parents favored the Rocky Mountains or resorts like the Sagamount Hotel near Joplin, Missouri, which billed itself as "the most glorious spot in all the Ozarks." A brochure that Louella kept assured that "[h]ere you will find respectable, quiet, sober people—the other kind would not enjoy it here—and are not wanted. No dangerous contraptions—no public dance halls—no beer sold."

Thus does this photo pull me beyond its moment, from the house with its lattice and awnings, its porch chairs and pots planted by my great-grandmother, through the trees to the Kansas City of 1940—not a place of respectable, quiet and sober reputation, but a town that was changing.

## Chapter 2
# From Boss to Gandies

*I knew Kansas City well in the 1930s. I worked there. I lived there…Today, one can no longer bump into gangster gunfights, see waitresses in the all-together, find jumping jazz combos, free shrimp or even the Blues…And if one chooses to become a bit morally philosophic about it all—the music is all that deserves to be remembered.*
—John Cameron Swayze

### 5650 Ward Parkway

Sometimes, on muggy summer evenings when they were looking to cool off, the Hamiltons would pile into the car and go for a drive along the city's boulevards, seeking a breeze. It was a popular pastime, one not lost on the Kansas City Public Service Company, which in 1940 began running an open-air sightseeing streetcar, "The Scout," around the city.

One outing highlight for motorists and Scout passengers was the vaguely French-style mansion at Fifty-seventh and Ward Parkway that belonged to Thomas J. Pendergast and his wife, Carolyn.

This year, Mr. Pendergast—the Hamiltons always called him that—had been serving time in prison for income tax evasion, the upshot of his obsession with placing bets on horse races without paying taxes on winnings. In spring, he was freed and returned to his house. Perhaps he didn't think of it as a home; he had never been as happy here as when the family lived

# Kansas City 1940

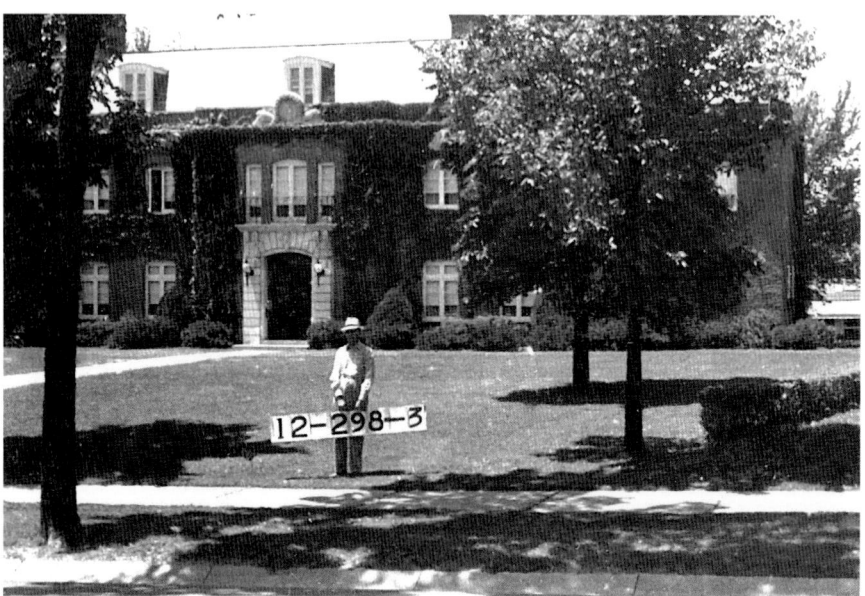

The Pendergast home, 5650 Ward Parkway.

east of Loose Park, in the buff-brick house with the red-tile roof on the corner of Fifty-fourth and Wyandotte.

On Ward Parkway, the Pendergasts were neighbors to some of the city's elite citizens—the J.C. Nicholses, the Robert Sutherlands, the Dr. Logan Clendenings and the Napoleon Dibles—but they had never been accepted by elite society, even as day-to-day business in the city had long been Tom's way or the highway. No more.

It was Nichols who made the Pendergast dream house happen a dozen or so years earlier. The story went that Nichols told him that the lot would cost $5,000, and Pendergast pulled out a roll of thousand-dollar bills. The Nichols Company architect, Edward Tanner, designed the house, and the Nichols construction department built it. It cost $175,000 and had rich wood paneling, an ornate marble bar, plenty of artwork and French-style furnishings, all inspired by the Pendergasts' European trips.

After he returned, it must have seemed an empty place. Friends and even some family members, embarrassed by his prison time, avoided him. His youngest child, Ailene, had gotten married and moved out, leaving him and Carolyn alone. His marriage was in trouble. His weakened heart was failing. It was hard even to climb the stairs to the grand master bedroom.

### From Boss to Gandies

Down at 1908 Main, at least, there had been an elevator, but he couldn't go there anymore. What he could do was look out the window of his Ward Parkway mansion on summer evenings and see the open-air streetcar and the automobiles full of people staring back, pointing.

## 1908 Main Street

For more than a dozen years, the second floor of this unassuming yellow-brick building on Main had been ground zero for political power in Kansas City and beyond. Downstairs, the Southwest Linen Company was still dispensing hotel tablecloths and such, and next door, you could still grab a bite at the Ever-Eat ? Café ("Ever Eat? Chicken or Turkey 35 cents—Air Conditioned"), a favorite lunchtime establishment of Boss Tom. Except that Boss Tom had been locked up in the United States Penitentiary at Leavenworth since May 1939, and the center of political gravity had shifted north several blocks, back to city hall.

Since 1927, this had been the home of the Jackson Democratic Club, long presided over by Thomas J. Pendergast, successful businessman and corrupt

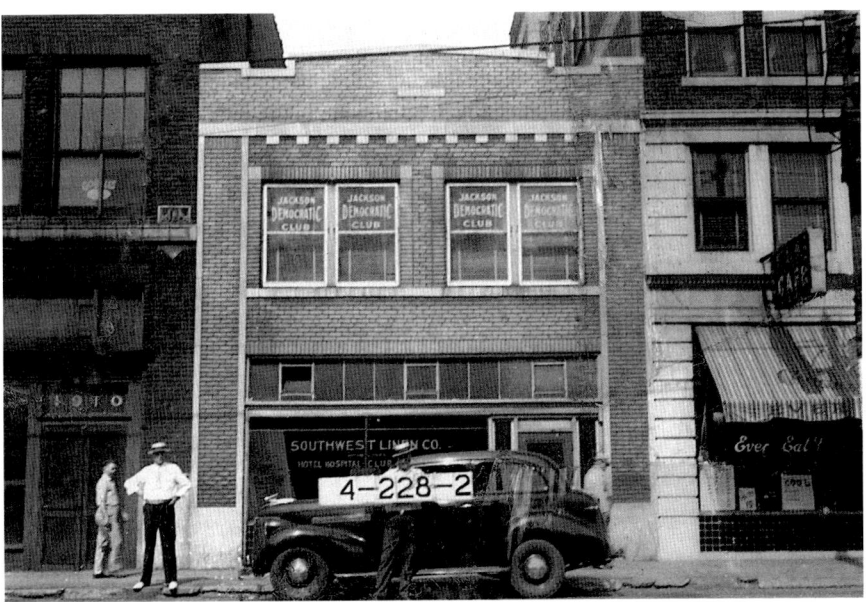

The Jackson Democratic Club, 1908 Main Street.

political boss. Although his official place of business was the Ready Mixed Concrete Company on West Twenty-fifth Street, this was where you came to wait in line with your request for a favor—be you unemployed laborer or member of Congress—three days each week from six o'clock to noon. That ended when he went to prison.

His time in Leavenworth was up as of Memorial Day, three months early for good behavior. Just before the April election for mayor and city council ended the Pendergast machine's control of city hall, the *Kansas City Star* had worried about the goings-on inside

> 1908 Main Street, from which Kansas City was ruled these fourteen years past, and which has been spoken of only in whispers in recent days…Sitting on the dusted-off throne seat of the imprisoned boss was his nephew, Jim Pendergast—receiving reports from the ward leaders, giving the last-minute instructions.

There would be accusations that Tom was secretly directing this year's reelection campaign of Senator Harry Truman, considered by his enemies to be a Pendergast puppet. "Absolutely nothing to it," said nephew Jim.

The Boss was free, but it was a new day in Kansas City. Reformers had taken over city hall. And sixty-eight-year-old Boss Tom, now in failing health, was spending his days not at the Jackson Democratic Club but at the Ready Mixed plant, banned from politics and from 1908 Main by the terms of his probation. "I intend to be on the job attending to business every day," he told the *Kansas City Journal*. "My office is open to those who desire to discuss business and personal matters, but not politics."

## 414 East Twelfth Street

Until this year, the thirty-story building at Twelfth and Oak was a locus of bad government, courtesy of the Pendergast machine. Just before the April election, a letter to the *Star* suggested the machine's legacy:

> A record of faithlessness that is unparalleled in history, a city so corrupt that its citizens had to apologize for it wherever they went. Elections so crooked that Mexico took a back seat, and a fiscal policy that puts to shame the armed bandits that prey on the banks and payrolls of the country.

### From Boss to Gandies

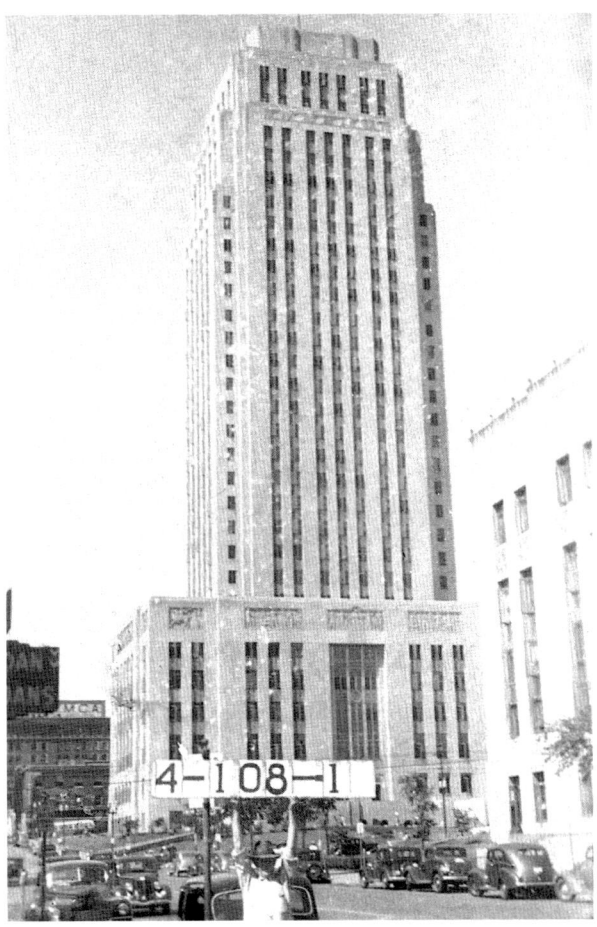

City hall, 414 East Twelfth Street.

A summer ago, the man who did Boss Tom's bidding here in city hall, former city manager Henry McElroy, died while awaiting trial for income tax evasion, having resigned in disgrace months before. (His troubled daughter, Mary, ended her own life early this year.)

Since then, an independent auditor's report had confirmed transgressions listed in the letter to the editor: McElroy used much of the $32 million (and a subsequent $9 million in federal aid) that Kansas City voters approved in 1931 as the Ten-Year Plan—a bond program to pay for civic improvements—to keep the machine well oiled.

He put Pendergast loyalists on the city payroll without requiring any work. He hired Pendergast-approved contractors without requiring competitive bids or invoices. He paid expenses to Pendergast-owned companies for things like

twelve sets of tires in a year for two city automobiles. He administered a policy whereby taxpayers could pay to have their property taxes reduced. He handled debt by wiping it off the books, a practice he called "country bookkeeping." The upshot: The city now owed $1 million in back salaries previously withheld from city workers. And not enough remained of the Ten-Year Plan funds to pay for its promised trafficways.

In early March, 125 members of the South Central Business Association filled the banquet room of the Blue Bird Cafeteria on Troost for a special luncheon. The president of the Lawyers Association introduced the speaker as "a man who approaches every problem with an intelligent courage, to whom nothing is satisfactory until it is done right," and then surrendered the podium to fellow attorney John B. Gage. It was the fifty-three-year-old Gage's first speech as the reform candidate for mayor.

Gage told them that deficits the Pendergast machine created were incredible but not something a healthy business community couldn't overcome. "The way to get out of the woods is not by higher taxes, but honest city government and a vigorous civic forward attack," he said. "If we don't get efficiency in city government, then the city's road ahead is indeed dark."

The April election was made possible by a February election that was, in turn, made possible by reformers. Citizens such as Rabbi Samuel Mayerberg had been speaking out against machine politics for years with little success. With Pendergast and McElroy finally out of the way, Mayor Bryce Smith refused to cooperate with machine councilmen and subsequently resigned. Women wearing little brooms pinned to their coats began gathering signatures—100,000 names—for a clean-sweep election to change the city charter and reduce a councilman's term from four years to two. That passed five to one. In April, the women made phone calls for the reform ticket and chauffeured voters to the polls. Machine councilmen were ousted, and John Gage took over the spacious mayor's office once occupied by City Manager McElroy.

The careful search for a new city manager led to an outsider: L.P. Cookingham, forty-four, former city manager of Saginaw, Michigan. His record matched what Mayor Gage sought: tax reduction, civic improvements and pay-as-you-go government. Cookingham began on June 1. In his first public address, he told his audience that he thought the city was ready for a new type of government. "There is no reason why Kansas City should not be the best city in the Middle West," he said. "It has everything to be a great, growing, dynamic city."

There was still the matter of trafficways, but by the end of the year, the number of workers on the city payroll was half its McElroy total. A merit system was in place, as were new systems of budgeting, purchasing and accounting. "The people of Kansas City are the government," said Cookingham. "We are their servants."

## 1125 Locust Street

The two-year-old building at the corner of Twelfth and Locust was headquarters for no-nonsense law enforcement, a trim ship skippered for the previous year by one Lear B. Reed, chief of police. "There will be none of the disgraceful tactics of the past during my regime," Reed said in July 1939 after the state took control of the machine-run department and put the former Federal Bureau of Investigation agent in charge. "Kansas City is being cleaned up and will be kept clean."

In January, just six months into the job, Reed dissolved the vice and gambling squad, declaring that the formerly "wide-open" city was now "viceless." Since taking over the department, Chief Reed had:

- fired about one-third of the department's employees;
- ordered employees in labor unions to resign those memberships and to report rule infractions by co-workers;
- changed police uniforms from traditional blue to brown, required officers to shave off mustaches and made the .38-caliber revolver the standard sidearm, ending the policy of allowing officers to choose weapons;
- ordered the disposal of confiscated items—gambling devices, license plates from stolen cars, liquor bottles and more—by dumping them from the Armour-Swift-Burlington (ASB) bridge into the Missouri River;
- cracked down on public drunkenness and begun a campaign to eradicate wild marijuana plants and "the horrifying effects of the use of this vicious weed";
- instructed officers to watch for Nazi sympathizers, saying, "We're not going to make them sing 'God Bless America,' but we do want to know who they are";
- sponsored sports at a youth club in the North Side neighborhood that spawned Pendergast henchman Johnny Lazia and other young criminals of Italian descent;

# Kansas City 1940

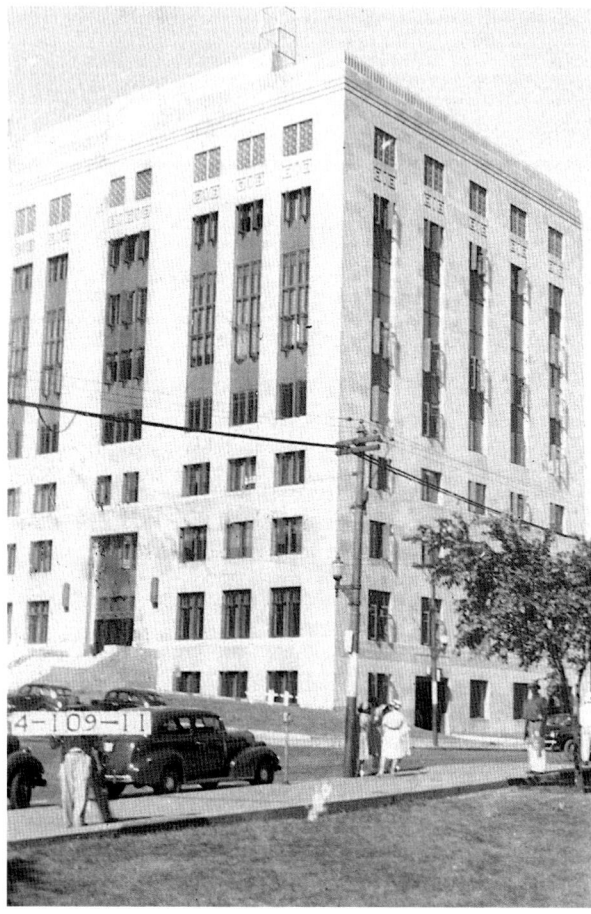

Police headquarters, 1125 Locust Street.

- ordered a search of "Negroes" in taverns "as a precaution against knifings";
- conducted checkpoints to test automobiles for faulty equipment and declared war on speeders, whom he called "Hitlers of the Highway."

It hadn't been easy. He received bribes of liquor and sex. He found daggers in his car, poison candy on his desk and the ace of spades—with a bullet hole—under his door.

At the FBI, Reed had worked on the Lindbergh kidnapping, the pursuit of Charles "Pretty Boy" Floyd and the Union Station massacre. In a St. Louis raid, a mother of four had been killed by shots that Reed fired through a door. He was charged with manslaughter but later cleared. Now a reputation for rough stuff seemed to have attached itself to his department.

## From Boss to Gandies

There was just one fight reported at February's election, but it ended with a punch delivered by Chief Reed. That same month, a detective shot dead an unarmed eighteen-year-old Paseo High School boy fleeing from a stolen car; he was charged with manslaughter and later absolved. Then Reed was charged with unlawfully fingerprinting and photographing persons but was subsequently cleared. In May, two officers were charged with felonious assault in the beating of a black teenager; a judge dismissed the case for lack of evidence. A man charged with speeding claimed that two officers beat him after he challenged his arrest. When the county sheriff said that he wouldn't accept any prisoner who showed signs of a beating until after a hospital examination, Reed scoffed. "I suggest the sheriff hire a physician for the jail," he said. "We'll continue to take prisoners over when they belong in the county jail and we'll expect them to be received."

In the summer, the department posted highway signs at the city limits: "Fireworks prohibited in Kansas City. Violation means confiscation & arrest." The city's ordinance forbidding illegal fireworks—pretty much anything but sparklers and cap pistols—had been around for years and was largely ignored. The police were usually the worst offenders, and the old police headquarters was often a war zone of smoke and fury on Independence Day. A year earlier, to spare the new building, they had taken their firecracker-loaded slingshots outdoors. That was a week before Chief Reed took over.

This summer, fireworks sales were down and the city quieter. The chief later admitted that his principles were old-fashioned, if that meant "respect for the Deity, America and womanhood…These time-tested virtues are not being sufficiently impressed upon our young folk. They know their arithmetic and their English, but they know more about Scotch, bourbon and the latest dance steps than about Americanism. I'd like to see a girl who wears a starched petticoat again, and one whose complexion didn't come out of a drugstore."

## 602 East Twelfth Street

One block east of police headquarters, there was evidence for Chief Reed's declaration of a "viceless" town. The "House of Swing" had closed, and its homely neighboring storefronts were quieter than they had been in years. If you liked that change, you celebrated Governor Lloyd Stark for his crackdown on vice. "A stench in the nostrils of the

# Kansas City 1940

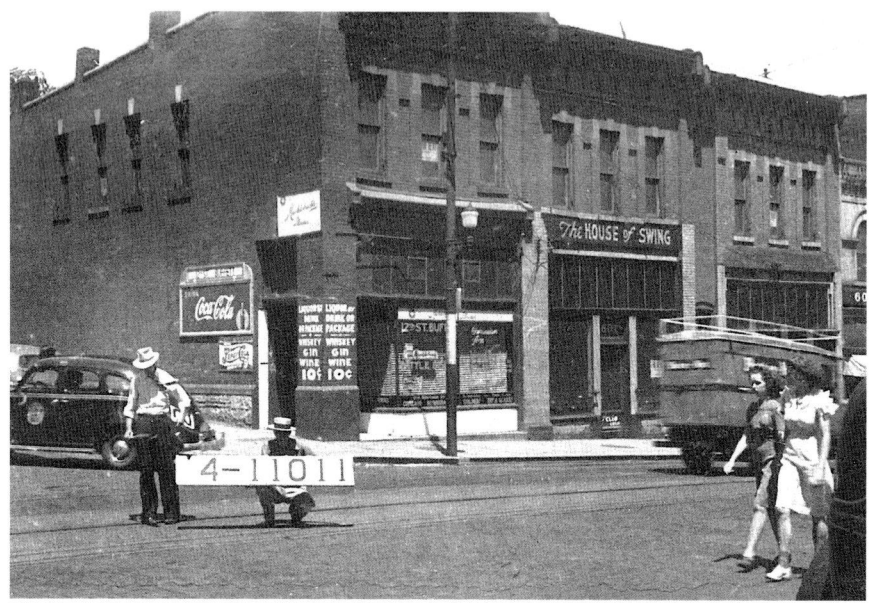

The former Reno Club, 602 East Twelfth Street.

decent citizens" he had called it as he shuttered some of the most popular establishments in town.

Twelfth Street still had its bars, cheap cafés, pool halls, shooting galleries, cigar stores and dime movie houses. But a year earlier, this stretch had been an open riot of neon, clinking glasses, tipsy laughter, near-naked ladies, clicking dice and swinging jazz, much of it literally in the shadow of police headquarters. The lineup of clubs included the Bowery, Club Continental, Dante's Inferno and Bar Le Duc (with their female impersonators), as well as the Reno Club, King Kong Lair, Six Hundred Club, Nut House, Amos 'N Andy, Green Leaf Gardens, Ace Night Club, Red Lantern, Old Spinning Wheel, Martini's, Lone Star Garden and the Sunset Club, where Pete Johnson pounded piano and singing barkeep Big Joe Turner sometimes stood in the middle of the street "calling his children home."

That was just Twelfth Street. Nightclubs studded several neighborhoods. It was the sort of nightlife that drew adventurous tourists, wide-eyed cowboys and traveling salesmen, as well as locals known to enjoy a good time now and again. It was good for business, legitimate and otherwise, so it had Boss Tom's stamp of approval. Eventually, it also drew notice from national journalists, who likened Kansas City to lascivious Paris. For the governor,

## From Boss to Gandies

who also happened to be poking around in Boss Tom's income tax returns, enough was enough.

The rough-edged jewel of the scene had been the "House of Swing," better known as the Reno Club, two doors east of Cherry Street. Sol Stibel ran it, a Polish Jew who had immigrated in 1913. Stibel first had a barbershop on the east side but was said to be involved in the Pendergast machine. Some years later, he closed the shop and opened the Reno, perhaps seeing his chance for a piece of the no-limits action.

The Reno had a long bar and a balcony overlooking a small bandstand. The crowd was racially mixed, separated by a partition. It featured hour-long floor shows deep into the wee hours. Between shows, the house band played sets. The house band eventually became a nine-piece group led by pianist Count Basie. They played seven nights a week and earned fifteen dollars each. A teenage Charlie Parker was known to drape himself over the balcony railing, absorbed in the sidesaddle sax style of Lester Young. Between sets, musicians took breaks out back near a food shack serving crawdads, chicken thighs and sandwiches of chicken wings, brains, pigs' feet and snouts. The sweet smoke from ditch-weed cigarettes hung in the air.

Performances were broadcast by local experimental radio station W9XBY. The signal was strong enough to reach Chicago, as well as the car radio of New York record producer John Hammond, who loved what he heard and made the trek here to see the Basie band live. In 1936, Hammond signed the men to a contract and carried them away to the big time.

Four years later, a quieter town didn't necessarily sit well with everyone. One woman wrote a letter to the *Journal*, doubting that the city needed cleaning up. "Any housewife can tell you a too-clean house doesn't have that sort of homey, lived-in look," she wrote, concluding, "Here is the point: They have closed up, tightened up, taken away a lot of good things that made visitors long to come here. After all, when hotel men have empty rooms, when people deliberately plan their travel to avoid us there must be something wrong."

# 1812 Main Street

The metaphorical cleansing of Tom's Town was spilling into the streets, becoming literal: a "Clean-up, Paint-up, Fix-up" campaign sponsored by the Junior Chamber of Commerce. "We want to get people thinking about

# Kansas City 1940

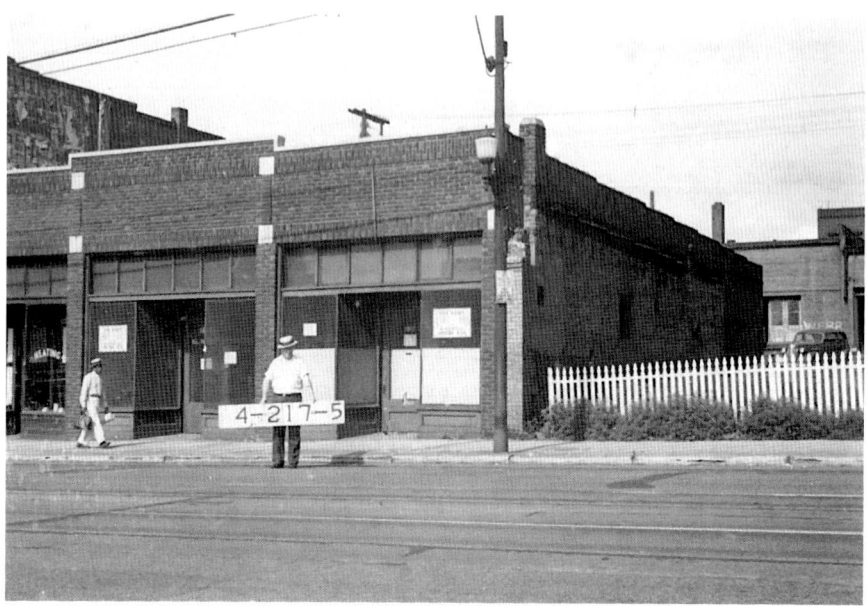

The picket fence at 1812 Main Street.

fixing up their houses and painting, cleaning up their property," said the Jaycee chairman.

To get things started, they chose a vacant lot on Main, between Eighteenth and Nineteenth Streets, littered with empty liquor bottles and rusty tin cans. One day, fifteen Jaycees were out there in a drizzling rain, filling a truck with trash, swinging sickles and dragging rakes across the weedy lot. They washed windows in the vacant building next door and painted the lower half of the windows gray to disguise the emptiness. As a final flourish, they built and painted a little picket fence.

"We are going into this in a big way," said the chairman. "We desire to give the whole city a bath—get behind the ears."

For quite some time, the marquee on the Mainstreet Theater at Fourteenth and Main announced that it was "Closed for the Summer." Actually, the theater had been closed for four years. Some folks looked at the sign and saw a run-down business district.

It seemed it wasn't just government that was fouled during the machine's rule, but also the city itself. There was the air problem—too much smoke and soot from chimneys, smokestacks and exhaust pipes. There was the noise problem—loud radios, barking dogs, the revving of engines and

indiscriminant blaring of auto and truck horns. And there was the problem of filthy sidewalks and vacant storefronts.

So the city passed an anti-noise ordinance and began cracking down on those who violated the existing ordinance regulating smoke. Downtown businessmen aimed to do something about the appearance of their district.

"What helps the downtown district helps all of Kansas City," said Grant Stauffer, chamber of commerce president, addressing a group of real estate executives. Creating the most attractive downtown in America, he said, in turn creates a prosperous city. And then he took it further: "Some speak of a return to the old civic spirit, but I'm all for a new Kansas City spirit of intelligent enthusiasm and determination to solve today's problems."

The city should also have the greatest education system; be the greatest center for art; build the smoothest, best-maintained streets and parking lots; and have the finest system of trafficways in America, he added.

To many listeners, this last idea appealed more than painted windows or picket fences. It was "probably the greatest opportunity since the opening of the Hannibal Bridge across the Missouri River," the *Star* editorialized, "to undertake the mighty but blessed task of rearranging streets and opening up new trafficways. It is almost the job of remaking downtown Kansas City."

## 526 Westport Road

Sawyer Material sold building supplies like plaster and cement. It also sold coal. Sawyer was but one among many coal dealers here. Unlike in a few American cities, it wasn't hard to get coal in this town. Kansas City sat in the middle of a coal region stretching from central Iowa to southern Oklahoma. By 1940, Missouri had been producing coal for one hundred years and Kansas for seventy.

The coal came in many grades, under many names: Paris, Eagle, Tiger, Rich Hill, Elmira, Red Feather, Indian Head, Black Rose, Blue Diamond, Acorn, Cherokee Red and Fancy Excelsior Springs Lump. The best was advertised as "high-heat," which created less ash and was described as "smokeless."

When you bought coal to burn in your home furnace—typically paying a few dollars per ton—you phoned a supplier, which sent a delivery truck that funneled the load through a chute directly into your basement. One supplier offered a free chicken with every ton. "Coal's our business,

## Kansas City 1940

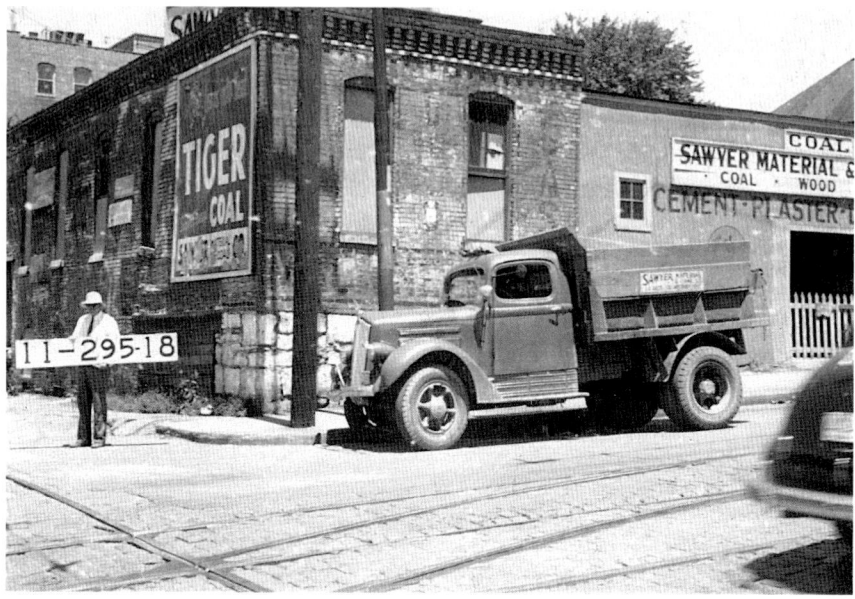

Sawyer Material, 526 Westport Road.

chicken's our hobby," said the newspaper ads. "We raised the chickens and mined the coal."

Beyond private residences, coal was burned everywhere—in apartment houses, commercial buildings, factories and railway locomotives—creating dense smoke and ash, which rose from smokestacks and chimneys into clouds that filtered the sun and then returned to earth as soot fall. Soot was everywhere: on statues and building façades, on shirts and sheets pinned to clotheslines, on curtains and rugs and tablecloths and in the lungs of pedestrians. A concerned reader wrote to the *Star*:

> *I am sure I speak for many housewives when I say the smoke in the city gets worse each year, and no woman wants to slave to keep a home clean under such trying conditions. It is no wonder persons are moving out of town. They prefer the extra expense of transportation to the extra expense of added cleaning and laundering.*

As part of the broader civic cleanup, the city counselor's office issued warrants for the arrest of executives of several laundry companies, citing an old city ordinance against the emission of "dense smoke" for

## From Boss to Gandies

longer than five minutes in any single hour. First it would be laundries and then railroads perhaps later. There was no mention of cigarettes or automobiles.

## 30 West Pershing Road

Air travel fascinated people. Every summer weekday, up to three thousand crossed the Hannibal Bridge to Municipal Airport just to watch the big, shiny Douglas DC-3s and Boeing Stratoliners take off and land. On weekends and holidays, it was maybe fifteen thousand.

A businessman could get to Chicago in less than three hours on Transcontinental and Western Air for under thirty dollars per round trip. It had become possible to go up and back the same day. TWA planes had just begun offering radio at each seat, and Braniff Airlines was proud of its "full-course, hot meals graciously served by lovely college girl hostesses."

And yet most people still came and went via twenty-six-year-old Union Station, riding Fast Mails, Chicagoans and Pacific Limiteds ("Finest in Deluxe Travel," the ads promised); Scouts, Chiefs and Super Chiefs ("Bigger, Roomier, More Powerful"); or Eagles, Southern Belles and Silver Streak Zephyrs ("Streamlined for Speed, Styled for Beauty, Designed to Provide the Most Luxurious Travel Service in the World"). Soot darkened the ornate ceilings of the waiting room and lobby; diesel engines were still new, and Missouri coal powered most locomotives of the twelve-passenger railroads that rolled through the sheds.

Local folks had jobs here. Bert Wagner, for instance, snipped hair in the station's barbershop. Lottie West of the Travelers' Aid Society answered questions in a lobby booth. Others worked in the candy and fruit stand, the cigar kiosk, the beauty parlor, the book and toy shop, the shoeshine stand, the tailor shop, the drugstore or the Fred Harvey restaurant. Some jobs began here and ended in another town—Louis Singleton cooked for the Chicago, Burlington & Quincy; Leo Browne served it up on white tablecloths for the Missouri Pacific; and Roscoe Hudson sorted letters for the U.S. Post Office in a mail car attached to a Rocket or a Ranger or a Silver Streak Zephyr.

The paying customers were salesmen with samples, politicians with speeches and vacationers with decal-covered grips. They were actors Edward G. Robinson (on screen this year in *Brother Orchid*) and Mickey Rooney (*Andy Hardy Meets Debutante*); Frank Lloyd Wright, with a design for a new church near the Country Club Plaza; Bill "Bojangles" Robinson, starring in *The*

# Kansas City 1940

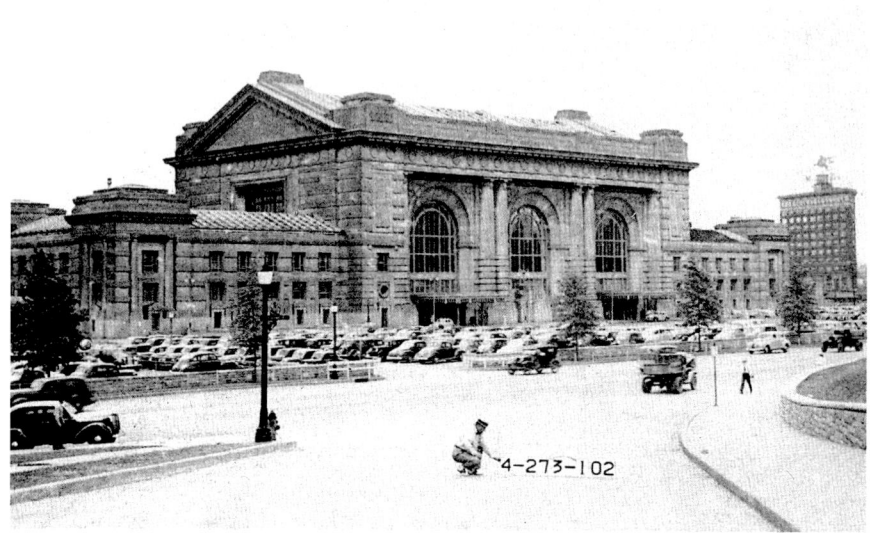

Union Station, 30 West Pershing Road.

*Hot Mikado* and fresh from the New York World's Fair; David Francis Clyde Jr., fifteen-year-old English refugee from Nazi bombs; Marian Anderson, with the lovely contralto heard a year earlier from the steps of the Lincoln Memorial; and Wendell Willkie, Republican presidential nominee, hoarse from speechifying and needing a day's hotel rest.

They also included an expectant mother from Chanute, Kansas. Her train pulled in one night at 10:30 p.m. At 10:45 p.m., she lay in the station's first-aid room. Next morning, a paragraph in the *Times* carried the tiny headline:

*A Baby Born at Station*
*Chanute Negro Is Mother of the Child*

The article provided no names, but it didn't matter. Another traveler—a boy, seven pounds—had arrived in Kansas City.

## 100 West Twenty-sixth Street

Thomas O'Leary walked out of Union Station and into summertime Kansas City. For several days, the mercury had been climbing past one

## From Boss to Gandies

Liberty Memorial, 100 West Twenty-sixth Street.

hundred degrees by late afternoon. Shade and electric fans provided small relief. Ads warned against the dangers of B.O. (Wife: "I worked so hard on the bazaar committee, yet I was treated like a nobody today!" Husband: "Dear, it's been hot for all that work and worry. Why don't you use Lifebuoy as I do?") Movie theaters were air-cooled, but not much else was. And what could you do when it was still eighty at midnight? Leary, a bespectacled man in short sleeves and gray slacks, carrying his suit jacket, climbed the grassy hill to Liberty Memorial.

When the sun went down, many folks flocked to Penn Valley Park, where they could try to catch a hilltop breeze near what many called the War Memorial. You saw them there, draped over the limestone parapet, gazing at the tepid fountains or the lights of downtown. Or they went to another park, perhaps Swope or Loose or—if their skin was dark—Parade, all of them seeking the relative comfort of a blanket on grass under the stars. Never mind the chigger bites.

The men wore short-sleeved shirts and long pants, which young ones rolled above their ankles and older ones secured with suspenders. A few neckties could be seen, as well as many straw hats. Most women wore dresses; only younger ones were in shorts. Lots of folks removed their shoes.

# Kansas City 1940

They'd brought picnic baskets and portable radios that broadcast war news and swing tunes across the lawn. There were croquet games played under streetlamps and free concerts given by the WPA orchestra.

As the heat abated, many people finally would go home. There they might linger a while longer on the front porch, lights out so as not to create more heat. They drew a cold bath. They applied a wet washcloth to forehead or tied ice cubes under wrists. They hung damp sheets in a bedroom window or put a cake of ice in a pan on the floor. Or they simply retired to a cot in the basement.

Down at the War Memorial, the temperature had dropped to near ninety degrees. Ted Leary was sprawled on the grass of the mall in his short sleeves and gray slacks, arms folded behind his head, one shoe off and one shoe on. His hat and his pipe lay nearby on his neatly folded suit jacket. He was a news agent who traveled by train, selling newspapers, stationery, postcards and such to customers from here to Oklahoma City. And this, he said, was the coolest spot in his territory.

## West Seventeenth and Jarboe Streets

The overheated could seek refuge at the West Terrace pool, with views of the stockyards and the West Bottoms. On this day, all was quiet. One little girl sat at the limestone entrance, perhaps awaiting a friend. It was a contrast to opening day, just before the summer solstice, when kids began lining up at 6:00 a.m. to be ready when the doors swung open at 10:00 a.m.

The triangular pool at West Terrace Park was a wading pool, one of eleven around town. The Parks Department also operated three full-size pools—for white residents at Penn Valley Park and the Grove and for black residents at the Parade. Hours were 10:00 a.m. to 10:00 p.m., seven days a week through August. At the swimming pools, girls and boys alternated days. On boys' days, the Red Cross lifeguards were men; women looked after girls. At the wading pools, the genders traded half-hour periods. Admission was free if you brought your own bathing suit and towel. It cost you a dime to rent a suit; three cents for a towel. You had to shower with soap before going into the water—no charge for the soap.

There was a small setback on opening day at the West Terrace pool. Waders arrived before chemicals did. The boys' half hour was first, and they were showered and ready, but the pool wasn't. "We ain't got any germs

## From Boss to Gandies

West Terrace pool entrance, West Seventeenth and Jarboe Streets.

left on us after all that scrubbing," one boy said. "Why we gotta wait to put germ-killer in the water?"

Likewise, it was boys' day at Penn Valley, but things didn't go smoothly there either. Low water pressure meant that the pool was still filling when the doors opened. Boys splashed in shallow water while girls watched them through the chain-link fence.

This year, the park board announced plans for a new pool in Swope Park near the lagoon. Swimmers had always used the lagoon when the bacteria count was low enough. The new pool would be built by WPA workers in time for the summer of 1941, large enough to accommodate thousands of swimmers—so long as they showered with soap and so long as they were white.

## 604 Winchester Avenue

The heat was harder on folks like the Contreras family, who lived across railroad tracks from the Sheffield Steel mill. A refrigerator was a luxury in

# Kansas City 1940

The Contreras home, 604 Winchester Avenue.

certain neighborhoods, and thousands of households relied on ice to keep food chilled. Sometimes even ice was a luxury.

Augustino Contreras lived here with his wife and eight children (a ninth had recently died of pneumonia). He was a fifty-nine-year-old Mexican immigrant. The previous year, he had supported his family on a WPA laborer's wages of $292.

So, nine-year-old August Contreras Jr. was eager to run to the corner of Independence and Cambridge Avenues early one morning to meet the truck with a few friends and a wagon. Thirty other neighbors—family of steel workers and railroad hands—were there too, waiting under a viaduct with buckets, wheelbarrows, cards and pennies. Everyone was waiting for ice.

Each summer since 1898, the *Kansas City Star* and the Salvation Army had sponsored the Penny Ice Fund, a charity drive that lasted from late June through September. The fund was built largely on public donations, many from children who put on neighborhood carnivals and front-porch vaudeville shows to raise money. Beneficiaries had to show need to receive an eligibility card. Applications came from people like the wife who sold flowers and doughnuts—enough to buy food but not ice—and the sixty-

five-year-old woman unable to walk, who wrote, "Please don't forget me as it's getting awfully hot." Each Penny Ice recipient paid a penny for a chunk of ice delivered by three Salvation Army trucks to thirty-six different street corners.

On this day, the truck was late arriving at the corner of Independence and Cambridge. The Sheffield area customers had been waiting more than an hour. When the truck finally arrived, the two deliverymen punched cards and took pennies and then removed the canvas from their load and started hacking away with ice picks. Two dogs lingered in a fine, cool spray of chips.

One freckled fourteen-year-old boy had been a Penny Ice customer for seven summers. He helped several neighbors by hauling their chunks on his beat-up cart. A former railroad engineer with long white hair, weathered skin and a sick wife at home said, "She's the one who needs the ice, not me. I'm in great shape for an old codger."

August Contreras Jr. and his young friends loaded their wagon with ice for three families. August held it steady with a pair of tongs. A woman wondered aloud what she would do if the Penny Ice stopped coming. "My family counts on it so much," she said.

## 2401 McGee Street Trafficway

Rose Kelly's home had outbuildings, vegetable gardens, chicken pens and shade created by young elm and mulberry trees. It rested on a foundation and had electrical service, making it a palace among the flimsy shacks on the limestone bluff near the busy intersection of McGee and Pershing Road.

The shacks, some no more than eight by ten feet, built with tarpaper, sheet metal, discarded lumber, bricks, stones and whatever else, were home to a dozen folks just getting by. Most, like Rose Kelly, were in their fifties or sixties, divorced or widowed or single, with only grade-school educations. Most had lived here a few years. Some paid rent for the land; others were squatters. Almost all were on relief or earned between $200 and $500 per year on one of the unskilled-labor WPA projects—the river, the sewers, the parks or the roads. Ironically, some might have been getting paid to wreck their own homes.

# Kansas City 1940

The Kelly home, 2401 McGee Street Trafficway.

Nearby a large red, white and blue sign read:

*A WPA Project*
*Pershing Road Grading*
*Sponsored by*
*Department of Public Works Kansas City*
*Work Projects Administration*
*Federal Works Agency*

The new Pershing Road trafficway was to bisect this makeshift colony. Four hundred WPA workmen had been digging the new road cut, a western portal to a future Southeast trafficway. Stakes marked the roadway's curve, cutting through Rose Kelly's homestead.

Workmen with shovels filled big trucks with Missouri clay. The trucks hauled the soil a few blocks to dump it west of Liberty Memorial or to the Union Cemetery, tracking over old grave sites to unload in a grassy area.

Other workers began moving the fragile squatter shacks out of harm's way, down through the trees into the sunlight. Rose Kelly's house was too large to move. She had to begin searching for a small house to rent somewhere else in the city.

## From Boss to Gandies

# 920 West Twenty-eighth Street

There were others, like Robert Perry, whose family lived in a three-room house at the corner of Twenty-eighth and Belleview, an all-white, working-class neighborhood. With no trade, Perry was a common laborer. He had last worked in spring, laid off by the WPA when appropriations were cut back. He said that he didn't blame the WPA—if not him, it would have been someone else. He said that he couldn't find any job, although the WPA had said that it wanted him back if new projects were created.

Perry received twenty-one dollars in relief groceries each month from the federal government, but he couldn't pay the twenty dollars in back rent, the electric bill or the final fourteen-dollar installment on a washing machine. His brother had been helping out but couldn't any longer.

One night, a neighbor with a car had rushed Perry's twenty-six-year-old wife, Mary, to the hospital. Robert wasn't able to visit her; he didn't have streetcar fare. Even if he had, someone needed to watch four-year-old Barbara and young William, three. Another family member was caring for the Perry triplets, Joyce, Janice and Jeanette, not yet a year old. And Mary had just given birth to twin boys.

The Perry home, 920 West Twenty-eighth Street.

## Kansas City 1940

Mary's fertility became a blessing. Reporters took note of her multiple deliveries in the previous year, and the Perrys' story wound up on page one of the *Times*. After that, a strange man showed up at the door with two dollars. "Use that for carfare to go and see your wife," he told Robert. "I've got kids myself." Three women arrived with groceries and then a man carrying bottles of milk. "That's all I can afford, buddy," he said, "but it comes from the heart." The mailman delivered a letter from another woman, with a dollar bill enclosed:

> *Dear Mr. Perry, Keep your chin up. God is with you, else He would not have entrusted you with so many beautiful children. I am praying that things get better for you, and when I pray, I get response.*

The WPA noted that Perry might soon be brought back to work on the intercity sewer project. Some men at the Kansas City Athletic Club who called themselves the Down and Out Club, for the rummy card game they played, learned about the Perrys from a newspaper columnist in their midst. They passed a hat at their lunchtime meeting.

Robert Perry was overcome. "Fella, I can't talk," he told the columnist, who delivered the sixty dollars and then reported it in his column. "That lady must have been right about her prayer. Tell the fellas how I feel, but I don't know the words. I just can't talk."

Soon after, a woman wrote to the Down and Out Club, asking for a radio. The members sent her a radio. Then came a letter requesting a washing machine. More letters arrived and more requests: a bicycle, home furnishings, assumption of a $250 note, an outfit for a girl going to college, $45 in cash, an automobile, payment of an $88 grocery bill and a suit of clothes size thirty-six. The Down and Out Club decided that its charity had ended with the radio.

## 520 Delaware Street

Unemployment was just below 15 percent, down nine points in the eight years Roosevelt had been president. Congress had appropriated less for the WPA, so thousands of Americans were losing their road-building, ditch-digging or tree-planting jobs. Some, in light of another overseas war threatening to boil over, were finding work in the new military buildup.

## From Boss to Gandies

The Big 4 Employment Agency, 520 Delaware Street.

If you needed a job, you might have checked the windows of the Big 4 Employment Agency, which displayed the hand-lettered possibilities for putting food on your table or on someone else's. Among the listings, you'd find farmhand, truck driver, dishwasher and waitress, each with its necessary distinction: *married* farmhand, *Mexican* truck driver and *white* dishwasher. Apparently, you could be any sort of waitress, assuming you were a good one.

The Big 4 was in the North End, the city's skid-row neighborhood. It was known as a clearinghouse for a specific type of seasonal worker. They were called gandy dancers, and they were in demand every spring. Railroads nationwide sought out the Big 4 when they needed crews of gandies.

A gandy dancer worked all summer, traveling from coast to coast and repairing railroad track. Because he was not a full-time resident of any

state, he wasn't eligible for government relief, although his paycheck was subsidized by assistance that the railroads got from Washington. He made $0.30 or $0.40 per hour and paid perhaps $1.25 a day for board.

In wintertime, the railroad work ended, and the gandy fended for himself with whatever he had left of his summer pay. Like many, he'd make his way to Kansas City, where the living was relatively easy. Flophouses costing thirty-five cents per night in Chicago charged fifteen cents here. Getting drunk on cheap booze was a pastime that could lead to panhandling or knocking on back doors for a hot meal. At night, he might sleep in a boxcar or under a newspaper. (Down in the West Bottoms, under a viaduct on Beardsley Road, more than thirty men had been sleeping by an open fire.) Or he could sleep in jail if he was among identified vagrants. Sometimes police rounded up hundreds.

If you needed work, you could also check the classified ads. Men were sought to pick potatoes in Levasy, Missouri; to rebuild wrecked autos in Great Bend, Kansas; and to drive dusty highways in Missouri, Kansas, Oklahoma and Texas, peddling ruffled curtains on commission. Men and women were needed to sell American flags to homes and merchants. If you were a "Couple, Colored" willing to stay nights, you could cook, clean, chauffeur and do yard work in another couple's home. If you were a boy of fourteen or fifteen, you could earn room, board and clothing for doing unspecified work. Girls over eighteen could provide curb service at the Phillips 66 at Swope Parkway and Benton.

It was said that not everyone who needed a job really wanted a job. The same newspaper columnist who delivered a donation to the unemployed Robert Perry family gave voice in his column to employment agency managers who swore that Roosevelt's relief was making people soft. "Been years in this game," one manager in the North End said. "Seems like folks don't want to work the way they used to. Some do, most don't. We don't fool with the fellas on relief. We can't get 'em to work. Would you want to work if you got dough for not doin' it?"

## CHAPTER 3
# From Vacant Lot to Modern Architecture

*When I think about America or Americans, there are ways in which I probably still think of Kansas City as the norm, against which everything else must be judged.*
—Calvin Trillin

### 215 WEST THIRTEENTH STREET

It was a typically eventful year at the five-year-old Municipal Auditorium. There was the NCAA basketball championship (Indiana trouncing Kansas). Marian Anderson performed for a standing room–only, racially mixed but segregated crowd, singing spirituals and "Ave Maria." The advertised "Biggest Event of the Season" was the Glenn Miller Orchestra playing hits like "In the Mood" and "Tuxedo Junction" for an arena-size dance.

There was the globetrotting Burton Holmes and his travelogues, beginning with "Heroic, Friendly Finland." The Four Ink Spots were here, singing "Bless You" and "If I Didn't Care." Fats Waller's performance included "Ain't Misbehavin'" and "Honeysuckle Rose."

Actress Tallulah Bankhead played Regina Giddens in Lillian Hellman's *The Little Foxes*. Bill "Bojangles" Robinson starred in *The Hot Mikado*, a jitterbug version of the Gilbert and Sullivan opera, on the road after its long stint at the New York World's Fair. Cornelius Vanderbilt Jr.—writer,

# Kansas City 1940

Municipal Auditorium, 215 West Thirteenth Street.

lecturer, world traveler and interviewer of heads of state—told a gathering of schoolteachers that war was inevitable.

Across from the auditorium sat a vacant city-owned lot. With spring's rain and sunshine, the lot grew weedy. One morning, as part of Police Chief Reed's effort to rid the city of what he called a "vicious weed," the cops stopped by the lot. Later, red-faced officials at the health department promised to destroy the wild marijuana plants before they went to seed.

The hot topic downtown was what to do with this lot, former site of Convention Hall, the auditorium's predecessor. More accurately, the question was: parking or park? The auditorium was near several streetcar and bus routes, but more people were driving cars, creating traffic congestion and searching for places to park.

Members of the Downtown Committee, a new group of business and property owners looking for ways to revitalize the central business district, wanted an official, moneymaking parking lot to accommodate events at the auditorium. Owners of existing parking facilities said, "Not so fast."

"I do not believe that it is necessary to open the auditorium lot for parking," said the chairman of the garage and parking division of the Automotive Trades Association. "Only on a very few occasions are the present facilities

## From Vacant Lot to Modern Architecture

filled to capacity. And if the lot should be opened, it would be likely to drive some of the present stations out of business."

The city council favored a new city park. The Building Owners and Managers Association passed a unanimous resolution against that idea:

> *The idea of a public and decorative park at this point* [is] *declared abhorrent, wasteful of the public funds, serving no useful purpose, requiring maintenance and expense to the city to keep up, and adding generally to the policing job of public authorities.*

The city and the parking garage establishment found themselves in league with lovers of natural beauty. "Kansas City has the dirtiest, ugliest and scrawniest downtown section of any city its size in the world," said one. "A few shrubs stuck around there to camouflage the parked cars will be no more beauty than three or four feathers stuck into the tail of a naked turkey. When I think of what could be done with that lot I think of John Keats who said, 'A thing of beauty is a joy forever.'"

## East Eleventh and Walnut Streets

The stretch of Eleventh known as Petticoat Lane was still the fashionable core of downtown shopping. Standing near Eleventh and Walnut, you were within a few blocks of numerous retail options, including Emery Bird Thayer, John Taylor, Klines, Wolferman's, Chasnoff, Jones, Jenkins, Rothschild's and more. The block right ahead, between Walnut and Main, was home to Helzberg's jewelers, Woolf Brothers clothiers—its streamlined Moderne corner façade topped by small green shrubs—and perhaps the finest jewel in the setting: Harzfeld's, selling women's wear for nearly half a century.

The July clearance sale was underway at Harzfeld's. You looked for bargains on summer hats and shoes, cotton dresses and lightweight suits. Summer store hours were from 9:00 a.m. to 5:00 p.m., and it was air-cooled inside.

The Downtown Committee's view was that downtown business was suffering from traffic congestion. To the *Star*'s editorial writer, it was a problem of streets having been "laid out in the horse-car days." The future was clear: "It must be conceived with vision that measures up to the progress of the motor car industry, that sees the motor car era with all its amazing possibilities for new growth and activity in Kansas City."

# Kansas City 1940

Petticoat Lane, East
Eleventh and Walnut
Streets.

A traffic expert from back east came to town, brought in by the Downtown Committee. Dr. Miller McClintock of Yale University was making a return visit to update a survey of traffic patterns done ten years earlier. The idea was to find out how shoppers got downtown, when they went and how much they spent.

In 1930, it had been a one-day survey. High school Reserve Officers' Training Corps (ROTC) members stood on sidewalks and counted pedestrians from 6:30 a.m. until 10:30 p.m. Store clerks counted customers and asked about transportation and purchases.

They found that almost 60 percent of shoppers came on streetcars or buses. People driving cars accounted for 24 percent. The motorists spent more money. People who parked in garages spent more than those who

parked on the street or those who used chauffeurs. The peak of pedestrian traffic came over the noon hour, and the busiest block was the east side of Main, near Petticoat Lane.

McClintock's 1940 study was also a one-day project that relied on store clerks querying shoppers. This time, the results showed public transportation bringing a little more than half of the customers and motorists accounting for 35 percent; 4 percent arrived on foot. In a public forum at Municipal Auditorium, Dr. McClintock said that he saw nothing surprising in the latest survey. "Many fundamentals of the 1930 survey will stand the test of 1940 conditions," he noted. "But we must recognize there have been many changes in the last decade. There are more cars on the streets than in 1930. That means a bigger traffic problem. Then, too, population centers have shifted, changing the points and directions of heavy traffic."

A man in the audience said that his wife had to walk a great distance when parking downtown. "Kansas City is fortunate in having space for ten thousand cars downtown," said Dr. McClintock. "And a little walking for your wife is a good thing."

Back east, where Dr. McClintock came from, finer stores were known for providing special services to finer customers. Now Harzfeld's was bringing a taste of that to Petticoat Lane: there was a uniformed doorman and curb service; your auto would be delivered to and from parking lots; and you paid the doorman twenty-five cents for the entire day.

## 1025 McGee Street

One day, members of the Downtown Committee's subcommittee on trafficways and parking piled into a bus and toured downtown. They listened as Police Chief Reed pointed out vacant lots and old buildings, identifying them as candidates for parking lots.

The old Hippodrome was near the end of its days. It was a low, ugly building at Twelfth and Charlotte Streets that sprawled over half a block. The Kansas City Public Service Company, citing old age, had contracted with a wrecking company to tear it down.

The building had begun life as a car barn for the old Twelfth Street cable car line. It later became a popular indoor amusement center in the style of the Pla-Mor, a place to go on Saturday night to roller-skate. Most recently, it had housed streetcars and buses. That use, too, faded away.

# Kansas City 1940

Parking lot, 1025 McGee Street.

Among the city's doomed buildings, the Hippodrome sat low on a scale of architectural splendor and utility. The high end was occupied by the Hotel Baltimore, described by one writer as having "belonged to a time that still measured luxury in terms of marble, red plush and space—particularly, plenty of space." But the Baltimore was coming down, too.

Others included the Alamo Hotel at Eleventh and Central Streets, three stories and seventy rooms that nobody wanted, and the Empress Theater on McGee, a former first-class, 1,300-seat house now out of favor—along with the vaudeville it presented—becoming what was deemed "a musty, cheap burlesque theater, unable to remain open more than a few months at a time, and several times raided by police for obscenity."

Another demolition project was the old bluff-top mansion overlooking the Blue River Valley. The Sheffield Steel Corporation owned it, but it was once Clarendon, the home of Colonel Daniel B. Dyer, a former Indian agent who died soon after building it in 1907. It had twenty-two rooms on three floors, Tiffany chandeliers, a multicolored glass fountain, carved-wood paneling and other parts of former buildings at world's fairs in Chicago and St. Louis near the turn of the century. Dyer's collection of Indian artifacts, long displayed in the public library basement, was being

## From Vacant Lot to Modern Architecture

moved into the new Kansas City Museum in the former R.A. Long home on Gladstone Boulevard.

The common denominator among all these structures was that nothing specific had been planned for the soon-to-be-vacant properties other than the creation of grassy lots or asphalt parking stations. Presumably they would look like the one here on McGee, which once had been a church.

## 818 Wyandotte Street

Dreams of a modern, auto-friendly downtown put remnants of the old city in danger. A half-century earlier, the eight-story, red-granite Gibraltar Building on Wyandotte stood at the city's financial center. Over the years,

Gibraltar Building, 818 Wyandotte Street.

# Kansas City 1940

the cast of characters in the Gibraltar had included Old Louie, the janitor who slept days in an unused room and worked nights; an architect murdered in his office by an associate with a brick; a parade of owners who swapped the building like a Monopoly property for a Colorado resort and a parcel of Mississippi; and Bill Bruno, chronicler of a dying industry.

Chicago once had been the center of the midwestern theatrical universe, but now it was Kansas City. People in that universe had hearts of nomads. Bill Bruno was one, although he no longer wandered the countryside. His stage was a tiny office here in the Gibraltar, where he published *Bill Bruno's Bulletin*, a weekly bible of tent shows—little repertory companies that toured small towns of the Missouri and Mississippi Valleys every summer, presenting comedy, tragedy and melodrama in tents, as they had since the turn of the century.

They traveled in caravans of beat-up cars, towing rickety trailers full of luggage and theatrical paraphernalia, hitting town after crop harvests, when money was best: western Kansas in wheat season, Iowa when corn was sold and Texas for cotton time. They pulled up at vacant lots near business districts, pitched their tents, solicited advertising and found housewives willing to donate furniture for props in exchange for tickets. Audiences were women holding babies on laps, men chewing tobacco and small children eager to show some talent for a chance to win a prize. Productions had titles like *Ten Nights in a Barroom*, *Rebecca of Sunnybrook Farm* and *The Man from Texas*.

Almost one hundred companies existed, each with ten to twenty actors. Every spring, managers came to Kansas City for tents, costumes, scripts and actors who would work for three dollars a night. Actors were older, character types happy to have work in hard times, or they were young and eager to make names for themselves. Hollywood stars who began on the circuit included Ralph Bellamy (seen this year in *His Girl Friday*), Jane Darwell (*The Grapes of Wrath*) and former Kansas Citian Wallace Beery (*20 Mule Team*).

*Bill Bruno's Bulletin* carried news about these companies, such as in this typical item:

> *The M and M Players, management of M.L. Mitchell, suffered the entire destruction of their top at Stickney, S.D. on Tuesday night of last week during a sixty-mile-an-hour wind storm, which closely resembled a tornado in violence.*

Bruno's parents were Swiss immigrants, and he had lived in Wisconsin and Iowa. Twenty years earlier, he had co-owned the Bruno-Guthrie Players, a traveling tent show troupe. He sold out, moved to Kansas City and founded

his *Bulletin*, living among actors, musicians and other itinerants in cheap hotels around town. He was divorced, had a kind face and a sharp tongue and set his copy by hand on the third floor of the Gibraltar Building.

In their spare time, show people helped him fold and stamp the *Bulletin*, reuniting with old friends and catching up on news. For years, tent shows had been losing audience to movies and hard times. Some of the luckier ones had found work in radio or in Hollywood.

Bruno, once a theater nomad and now fifteen years older than the Gibraltar, stayed with his industry newspaper. It was, of course, an industry with a motto: "The show must go on."

# 3015 Indiana Avenue

Remnants of the old city included folks for whom days were passing more quickly than they once did and for whom Glenn Miller's recent hit version of "Little Brown Jug" was less meaningful than the original version that came out in 1869, when they were young. They remembered not only the world war but also the Civil War, as well as wars between. For them, the "Great Depression" was the one in the 1870s, although they probably would have admitted that the recent one was worse. Anzy and Sina Allard, whose home was near Thirty-first and Indiana, were among these people.

One day, the Allards and others gathered at the Ivanhoe Temple on Linwood Boulevard, shuffling slowly, leaning on canes or the able-bodied and lining up to tell registration clerks which day in the nineteenth century belonged to them. Most were couples wearing tiny, colorful paper hats, giggling and pointing at each other. They sat in the big auditorium and looked to the stage with its huge American flag. Everyone sang "America," and then a pastor spoke:

> *This group is especially significant today when the "word given" means nothing, speaking in terms of nations. Nations no longer trust each other and one marriage in six is said to end in divorce. From the wholesomeness of this group, men and women who can keep a vow, and from such homes as yours, lies the hope of this old world to come back to honor and integrity.*

In 1940, the average life expectancy was 62.9 years. The several hundred members of this True Vow Keepers Club, people married at least fifty years,

# Kansas City 1940

The Allard home, 3015 Indiana Avenue.

had beaten the odds. To celebrate enduring love, they had come from several states around, although the Allards had come only several blocks. Scattered about the celebrants were a few quiet ones, those who came alone and provided two dates to the registration clerks: a wedding and a passing.

A square dance group took the stage, the Mark Twain Shufflebugs, swinging partners to "Billy in the Low Lands," heads bobbing across the second red stripe on the big flag behind them. Next came an accordion solo, a fiddle solo and a whistling solo. A prize was awarded to the couple married the longest. The Anzy Allards, both eighty-seven, having exchanged vows on March 19, 1873, were the winners. Their sixty-seven years of marriage won them a lamp.

Up on stage, the Never Grow Old Quartet—eldest member eighty-eight—brought back innocence with songs like "The Daring Young Man on the Flying Trapeze," "Polly Wolly Doodle" and "Carry Me Back to Old Virginny." Perhaps there was a song from the Allards' year, "Silver Threads Among the Gold":

> *Darling, I am growing old,*
> *Silver threads among the gold,*
> *Shine upon my brow today;*
> *Life is fading fast away.*

## From Vacant Lot to Modern Architecture

# 1617 Park Avenue

A widow named Anna James lived alone in the left half of this rented duplex, and she managed her building and the one next door. She had been in Kansas City twenty-five years, but like many of her neighbors, she was a native of the South. They came from Tennessee, Arkansas, Texas, Oklahoma, Louisiana or, like Anna, Mississippi. They were maids, janitors, cooks, dishwashers and WPA workers.

The neighbor next door was 42, a WPA seamstress who lived with her 13-year-old niece and 78-year-old mother. The mother would have been the block's oldest resident if not for Anna, who was 101.

Anna's life had begun in slavery on a plantation in Coffeeville, Mississippi. She claimed to have seen President Lincoln during the Civil War, although his only known visits to Mississippi were as a young man, working flatboats on the river. She was twenty-four when Lincoln signed the Emancipation Proclamation.

This year, *Gone with the Wind* had its gala Kansas City premiere at Loew's Midland Theatre downtown on a cold night in January. The line to buy tickets wound around the block in temperatures near zero. In February,

The James home, 1617 Park Avenue.

after the movie won Best Picture and nine other Academy Awards, the *Star*'s editorial writer wondered "after all the shouting dies, whether *Gone with the Wind* will be remembered as one of the really great achievements… comparable, say, to *The Birth of a Nation* or *Snow White*."

In spring, folks in Anna James's neighborhood got their chance during its four-day run at the Lincoln Theater, Eighteenth and Vine Streets. The review in the *Kansas City Call*, headlined, "No Offensive Parts in Film *Gone with the Wind*," sought to reassure readers of Margaret Mitchell's book. "The motion picture adaptation of that novel is discreetly free of insidious anti-Negro propaganda and other offensive matter," the review noted. It praised actress Hattie McDaniel for her Oscar-winning role as "Mammy." Perhaps Anna James, if she decided it was worth her time, sat in the darkened theater waiting to see something that might or might not have resembled whatever she held in memory.

Her neighbors knew Anna well, and they called her "Aunty." She was known for making beautiful quilts. They said that on clear days, if she was wearing her glasses, she could thread a needle with ease. In the April election, when she went to vote for mayor and city council, she had to ask for help with her ballot.

"How do you want to vote, Aunty?" the precinct worker said.

"Straight," she said, without hesitation.

"But which ticket?"

"Democratic, of course."

Given her history with the party of Lincoln, it might have seemed an odd choice. But when Aunty James died in November, after the presidential election and just shy of her 102$^{nd}$ birthday, she had lived in Kansas City almost as long as she had lived in slavery. She had seen what Pendergast and Roosevelt work projects had done for employment in her neighborhood—perhaps a different, more immediate emancipation.

## 2221 Denver Avenue

Sometime between *Gone with the Wind* and Charlie Chaplin's *The Great Dictator*, Loew's Midland showed *Andy Hardy Meets Debutante*. The film held special interest for the residents of this east side home.

Wade and Lydia Prewitt lived in the middle of a block where the neighbors were white, middle-aged laborers, clerks, salesmen, small-business owners

# From Vacant Lot to Modern Architecture

The Prewitt home, 2221 Denver Avenue.

and their families. Wade was a sixty-two-year-old steamfitter; Lydia was three years younger. The Prewitts had been married thirty-six years.

Lydia was a longtime Kansas Citian, with a brother, Harry, in town and a sister, Nell, in California. Years earlier, Nell, a former chorus girl, had left home for a vaudeville career. In New York, she married a comedian from Scotland, Joe Yule, and they had a son, Joe Jr. Toddler Joe, dressed in a miniature tuxedo, sang in his parents' traveling stage act.

Joe Yule Sr. turned out to be a drunken womanizer. In 1923, he abandoned his wife and three-year-old son; they then left New York for Kansas City, moving in with Wade and Lydia Prewitt. Nell's career appeared finished, but she decided that young Joe had talent for the movies. She packed him off to Hollywood to audition for Hal Roach's *Little Rascals* but ran out of money and had to return to her sister's home here. Two years later, they tried again, and this time, six-year-old Joe won a film part, playing a midget. Nell found work running a tourist home. Since then, life had been good. Joe was now known as Mickey Rooney, and Nell was the mother of the top box office star in Hollywood.

In the summer, *Andy Hardy Meets Debutante* opened here, latest in the series that made Mickey Rooney popular. He was turning twenty, creeping ever closer to adulthood and uncertain territory for a child actor. He still charmed his audience, but for some time, he'd had an off-screen reputation as a swaggering jerk.

# Kansas City 1940

Still, he was an Academy Award nominee for Best Actor this year, and before his birthday, he got a new contract worth $40,000 for forty weeks of work, plus a bonus of $25,000 for each of the five movies he normally made in a year. By December, he was tops at the box office once more, ahead of Spencer Tracy and Clark Gable.

Early this year, Mickey attended a bash in Washington, D.C., celebrating President Roosevelt's birthday with James Cagney, Dorothy Lamour, Edward G. Robinson and other movie stars. Returning to the coast, his train stopped briefly here at Union Station. His mother, Nell, staying with the Prewitts while Mickey was back east, brought family members down to the train platform to greet him during the fifteen-minute layover.

Lydia Prewitt carried photos that her nephew had never seen, among them a bare-bottomed infant and an eight-year-old costumed cowboy. Reporters approached for a few words from the star, who yawned and poked his thumb toward another man nearby. "See my publicity representative," he said.

Then he said goodbye to his family and reboarded the train to Hollywood, carrying the photos of Joe Yule Jr.

# 3446 Broadway

In the summer, some Paramount Pictures bigwigs came to town to preview their fall season for members of the press at the "refrigerated" Vogue Theater. Studio president Barney Balaban, Chairman of the Board Adolph Zukor and a few underlings tucked their hats into the folded seats in front of them and settled in for three hours of trailers for comedies like *I Want a Divorce* with Joan Blondell and Dick Powell, *Christmas in July* with Powell and Ellen Drew, *Second Chorus* starring Fred Astaire and Paulette Goddard and *Love Thy Neighbor* with Jack Benny and Fred Allen.

Apparently, the moviegoing public was shying away from Hollywood's anti-Nazi movies. The Paramount brass had decided that what they really wanted was laughter and escape. One of those war-themed movies that no one wanted to see was playing at the Uptown Theater, a few blocks down Broadway from the Vogue. *The Man I Married* starred Joan Bennett as a newlywed whose German husband turns out to be a Nazi. Also on the bill was a short film produced by General Motors, *To New Horizons*. It was a promotion for Futurama, the popular GM exhibit at the New York World's Fair portraying the America of 1960. The future, according to GM, was built on superhighways.

# From Vacant Lot to Modern Architecture

Vogue Theater, 3446 Broadway.

"The promise of new horizons always has called men forward," said a soothing voice as the camera panned a diorama of rural areas and suburbs and cities tied together with wide ribbons of concrete. "Mentally and physically, we are progressing toward New Horizons. We are approaching Futurama. The Greater and Better World of Tomorrow." There were scenes of lush countryside. "This world of tomorrow is a world of beauty," the voice assured. "A world which will always grow forward." The scene showed trees under canopies of glass.

Tomorrow's country highway was seven lanes wide, with different lanes for different speeds—fifty, seventy-five and one hundred miles per hour. "Safe distance between cars is maintained by automatic radio control," said the voice. "Without tedious travel, the advantages of living in a small town are within easy reach, bringing the people who live there into closer relations with all the world around."

The city of the future appeared, redesigned for separate and distinct uses—residential, commercial and industrial, "for greater efficiency and greater convenience." That meant expressways built through out-of-date business districts and unsightly slum neighborhoods. "Man continually strives to replace the old with the new."

# Kansas City 1940

The voice summed up the streamlined world of 1960:

> *A future which can be whatever we propose to make it. True, each of us may have different ideas as to what that future will be, but every forward outlook reminds us that all the highways of all research and communication, all the activities of science lead us onward to better methods of doing things…in the great American way.*

In the darkened theater, people sat quietly as the future was revealed. The credits rolled, and a man sighed and sized up the "World of Tomorrow," exclaiming, "Boys, it appears the Republicans have got in."

# 2022 Main Street

Just north of Union Station, next door to the Hotel Terminal, Kelly's Restaurant shared a building with the Third Ward Republican Workers Club. It was an election year, and under a photo of Wendell Willkie, the club's window proclaimed its support of Willkie for president and Forrest Donnell for governor.

Third Ward Republican Workers Club, 2022 Main Street.

## From Vacant Lot to Modern Architecture

Willkie was the surprise of that summer's GOP convention in Philadelphia, dramatically winning the nomination on the sixth ballot over other favorites, including New York City district attorney Thomas E. Dewey and Ohio senator Robert Taft. Unlike his opponents, Willkie had never run for office and didn't oppose U.S. aid to Britain's war defense. He was a businessman, a former Democrat turned critical of what he considered anti-business policies of Roosevelt's New Deal.

Across the country, lots of people—including many Democrats—opposed an unprecedented third term for Roosevelt. Many thought that the president was beating the drums of war to scare up support for reelection. Even the *New York Times* endorsed Willkie, as a way to guard "against vesting the enormous powers of the Presidency in the hands of any man for three consecutive terms of office."

In May, Willkie (then considered a long shot for the nomination) visited Kansas City and spoke at a Republican dinner at the Hotel Muehlebach. "I say to you from the depths of my heart that another four years of New Deal spending in this critical period will be ruinous to this country," he said.

Willkie needed the isolationist vote to get elected, but Germany's invasion of France and bombing of England put the war in new light. The official Willkie Club, downtown at Tenth and Walnut, hung a sign in its window: "This 'Preparedness Business' is a job for A Business Man. WILLKIE."

The women's division of the club threw a "political fair" for its candidate, an Indiana native who once had taught high school in Coffeyville, Kansas. The club turned GOP headquarters into a county fair, with cornstalks, quilts, stacked displays of jams and jellies, a spelling bee and a covered-dish luncheon.

An editor at the *Star* published his opinion on the front page. "Before the Constitution was deleted and streamlined by the New Deal, it called for a government of three functioning powers," he wrote. "Mr. Willkie's philosophy is simply to restore to the Constitution its original form." He said that he felt good about the election because he had noticed Willkie stickers on cheap old cars, not just Cadillacs and Packards.

Republican Chester Franklin, owner and publisher of the *Kansas City Call*, perhaps ignoring what the WPA had done for many of his readers, announced that he supported Willkie "because I believe that only under his leadership can America secure employment for that now jobless portion of American citizens of which the Colored race, of which I am a member, forms a large part."

Just before the election, a letter in the *Star* pointed out, "We have had 151 Novembers since the Constitution was adopted and not one of them

had a third term in it." The chairman of the Jackson County GOP warned of an American dictatorship and compared the New Deal's tactics to those being used by Herr Hitler. When any customers at one local bar urged a vote against an American dictatorship, waiters turned up one jacket lapel to reveal the "We Want Willkie" button pinned there. The opposite lapel similarly concealed a Roosevelt button.

And on November 5, by a comfortable margin, the president won his historic third term. Members of the Third Ward Republican Workers Club did not go home empty-handed. Forrest Donnell was the new governor.

## 2444 Montgall Avenue

The northwest corner of Twenty-fifth and Montgall was home to John Bluford; his wife, Addie; and their grown children—two sons and a daughter. The Blufords had lived in Kansas City since moving from North Carolina in 1921. Their block of Montgall was black; whites lived one block east on Chestnut and one block west on Prospect.

Bluford, sixty-five, taught science at Lincoln High School. One son taught college; the other was district manager for an insurance company. His daughter, twenty-eight-year-old Lucile, was managing editor of the *Call* weekly newspaper.

For readers of the *Call*, discrimination was a fact of life—from the housing situation to not being allowed to try on clothes in downtown stores, having to sit in separate sections at Municipal Auditorium and at Blues games and being banned from most public swimming pools. Whites were quick to say that black residents had their own pools (and seating areas and clothing stores and neighborhoods and newspaper).

An article in the *Star* reported that the Parks Department for the first time would be sponsoring the annual Emancipation Day celebration at the Parade Park, with music, sporting events and public speeches. The Parade was one park designated for black citizens.

Meanwhile, women who lived near Penn Valley Park protested the presence of black residents in a playground there. And out in Swope Park, four friends were told by a police officer that they had to move their picnic. The policeman said, "Ten acres are reserved for you near the zoo."

The *Call* responded to the latter with a front-page story, quoting the president of the local NAACP. "Swope Park is a public play or recreational

## From Vacant Lot to Modern Architecture

The Bluford home, 2444 Montgall Avenue.

area for all citizens to enjoy under lawful circumstances," he said. "While we do not wish to encourage peace disturbance of any kind, we do want all members of our group to know that there is no authorized rule or law restricting Negroes in the use of Swope Park, or any other public space."

The *Call* was, and had been since its founding twenty-one years earlier, a Republican newspaper, supporting the party of Lincoln. Founding publisher Chester Franklin endorsed Wendell Willkie for president, but in recent years, Franklin had been raising his paper's voice against discrimination, particularly as it applied to employment.

The city, noted the *Call*, owed blacks their fare share of city work; as they counted for 10 percent of the population, they should have about 500 of the 5,000 city jobs. The paper demanded that the new administration do better

than its predecessor, responsible for just 366 of those jobs going to blacks, most of those at General Hospital No. 2 (and not one clerical worker in city hall).

In September, developer J.C. Nichols, who had been in Washington lobbying for new defense factories in the Midwest, predicted one for the Kansas City area; Jackson County's ammunition plant became official in October. In December, a bomber assembly plant was awarded to Kansas City, Kansas. The *Call* advocated for black residents in the defense work and called out the Civil Aeronautics Authority for allowing its Missouri Aviation Institute to bar such workers from its training program.

The pragmatic force behind the *Call*'s activism was Managing Editor Lucile Bluford, who had worked at the paper on and off since attending Lincoln High. An honors graduate of the University of Kansas, Bluford applied in 1939 to the graduate journalism program at the University of Missouri. She was accepted but was ultimately denied admittance when the registrar realized that she was black. She sued but lost a judgment in the case this year.

To read the *Call* was to understand that discrimination was not going away, and neither was Lucile Bluford. You heard her voice in the paper's coverage of a right-to-work rally at Municipal Auditorium, attended by thousands. You heard it in the quote from Reverend A.D. Holmes of the Paseo Baptist Church. "We're going to fight until we have the right to work in national defense as others do," he told the crowd. "You aren't going to win any war unless you treat the Negro right."

## 1115 Armour Boulevard

Ads appeared in newspapers and magazines for the Missouri Aviation Institute:

> *Learn Airplane and Engine Mechanics*
> *the Practical Way*
> *at a U.S. Government Approved School.*

The *Call* objected to this qualifier: "If you are a white American citizen and between the ages of 18 and 40 you are eligible for this training."

The school operated at the Municipal Airport, overseen by the federal government's Civil Aeronautics Authority. Two years earlier, Congress had established the independent CAA to oversee civilian air travel. Now the war

## From Vacant Lot to Modern Architecture

Boulevard Manor, 1115 Armour Boulevard.

in Europe had opened eyes to the lack of pilots in this country. In response, the agency administered a Civilian Pilot Training Program.

John Paul Morris ran the CAA branch here from an office on the ninth floor of city hall. Morris was a pilot, as were co-workers, including Jess Green. Both Morris and Green lived in the Boulevard Manor, an eight-story apartment hotel just east of Armour and Troost.

A new CAA hire this year was O.F. Trumbauer. With Green, he was responsible for the success of more than two thousand pilots at schools in a seven-state area. It was a new career for Trumbauer, who was much better known as Frankie "Tram" Trumbauer, jazz saxophonist extraordinaire.

Trumbauer, thirty-nine, was considered one of the top jazzmen of the previous twenty years, having played with many of the great bands and

# Kansas City 1940

players: Paul Whiteman, Benny Goodman, Artie Shaw, Jack Teagarden and the Dorsey brothers. His 1927 Okeh label recording of "Singin' the Blues," with Eddie Lang on guitar and Bix Beiderbecke on cornet, could bring as much as forty dollars in 1940. It was recorded a few years before he took his first flying lesson. Now he had his own plane.

In March, Trumbauer's orchestra finished a gig in Cincinnati, and he closed the lid on his horn for the good of his country. "This retirement from music doesn't mean I'm tired of it or that I think the business is through," he told a reporter. "It just means that I'm more interested in this new program that means so much to America's defense. We need all the pilots we can get and I want to do my part in seeing that we get them."

Trumbauer had not yet moved his family here from Los Angeles, and he probably followed his co-workers' lead and took a room at the Boulevard Manor. From there, it was a short walk around the corner to Milton's Tap Room, a jazz oasis where Julia Lee played a regular gig. The proprietor was Milton Morris, a veteran nightclub owner from the wide-open days and a man known to collect jazz records. It's a good bet Morris's collection included a copy of "Singin' the Blues."

It must have been odd for a jazz musician, even a white one, who surely had seen the effects of racial discrimination up close, to be sanctioning it in his new career. Sitting in the relaxed familiarity of Milton's, with Julia Lee as muse on piano, Frank Trumbauer might have wondered about life's strange realities.

## 3605 Broadway

The dice, the naked ladies and the nonstop flow of alcohol were gone, and with them many jazz musicians who lost gigs. But nightlife could still be found. Not all clubs had closed. Music was still playing.

Upstairs at this address was the Century Room, where as 1940 began you could dance from 9:00 p.m. until 2:00 a.m. for a cover charge of forty cents. It could be the Clyde Bysom Orchestra from Lawrence or maybe Jay McShann's Orchestra—with sax man Charlie Parker back in town—shaking the circular floor for your jitterbugging pleasure. There was free parking in the Congress Garage.

If you didn't pine too much for the wide-open nightlife, you could find no shortage of after-hours entertainment. Besides Julia Lee at Milton's or the Castle Theater at Twelfth and Paseo, there was Harlan Leonard's

## From Vacant Lot to Modern Architecture

The Century Room, 3605 Broadway.

orchestra at the Blue Room, inside Street's Hotel near Eighteenth and Vine, with vocalist Myra Taylor out front. Farther north on Troost, the Wiggle Inn billed itself as Kansas City's oldest nightspot. The Jungle, downtown on Tenth Street, presented three floor shows per night. Twelfth Street still had the Ace Night Club. You could take a free conga or rhumba lesson at the Southern Mansion on Baltimore.

For dancing, older generations generally went for the "sweet" sound, a staple in the ballrooms of the downtown hotels: the Sky-Hy Roof at the Hotel Continental, for instance ("Dance in the Clouds"), or the Terrace Grill at the Muehlebach, where you might have heard a dance band led by Red Norvo, "King of the Xylophone," or Little Jack Little's Orchestra. Little told a reporter that the slower, sweet stuff was more popular than swing music.

# Kansas City 1940

"Swing has a definite lift in rhythm, which often is carried to extremes," he said. "The beat of 'sweet' music is not so noticeable, the phrasing more legato. We are asked for it far more often than we are for swing."

Little said that he had seen signs posted in most ballrooms reading, "No jitterbugging allowed." But jitterbugs were alive and well upstairs at the Century Room; down on Southwest Boulevard at the State Line Tavern; over on Thirty-ninth at the Casa Nova; out beyond the city limits on Wornall Road; at Tootie's Club Mayfair and the White House Open Air Gardens; at the Pla-Mor Ballroom on Main and at the dance pavilion at Fairyland Park on Prospect, where summertime brought swing orchestras led by McShann, Cab Calloway and Count Basie; and in the many dance halls around town. A classified ad beckoned you to one:

> *Jitterbugs—Oakwood, 114–16 W. Linwood Blvd. Campus Capers Nite for the Younger set. 15 cents till 9, then 25 cents.*

Back east, a Methodist minister in New York City claimed that western civilization was threatened by four things: "excessive urbanization…the coarseness of our commercial amusements…the mad pursuit of the almighty dollar…[and] the violent imperialistic, nationalistic rivalries among the nations." He noted, "We are living in a jitterbug civilization in which we have lost all sense of direction…We are bound to the immediate and blind to the eternal."

Here in Kansas City, the second evil on that list apparently threatened reformers. In summer, the new city council revised regulations for establishments with dancing, including hotels, taverns and dance halls. They allowed sales of liquor or beer but barred anyone drunk or of "bad reputation." There would be no "vulgar, suggestive or immoral" dancing. And after 1:30 a.m. on weekdays or midnight Saturday, there would be no dancing, period.

## 104 East Fifty-ninth Street

Jitterbugs, apparently, did not buy groceries at Wolferman's. For one thing, not everyone could afford it. Most small grocery and supermarkets didn't stock the premium quality found in the four Wolferman's stores—here at Fifty-ninth and Main, on the Country Club Plaza, Armour and Main

## From Vacant Lot to Modern Architecture

Wolferman's, 104 East Fifty-ninth Street.

and the downtown flagship on Walnut—where the understated motto was "Good Things to Eat."

In them, you found locally grown fresh produce in season, butter and eggs from the company farm at Ninety-seventh and Holmes; English muffins and southern-style salt rising bread, baked every day in house; and cheesecakes and homemade chip-chocolate ice cream. There were baked beans, chicken croquettes, deviled ham, smoked liver sausage, sliced roast loin of pork and lamb patties circled with bacon—all prepared in the downtown kitchen. Seafood included fresh white bass from Lake Erie, fresh halibut from Alaska, live lobsters, fresh Chinook salmon, even fresh shad roe and frog legs.

Perhaps that was why seventy-year-old Fred Wolferman did business in proximity to some of the best real estate in town: Petticoat Lane, Hyde Park, the Plaza and the Country Club District. He knew who his customers were and where they lived.

This year, he wanted to know what they were listening to. For one week, all Wolferman's stores asked shoppers to vote for their favorite popular songs. There were other ways to take the musical pulse of Kansas City, though. By hanging around the dance halls and certain clubs that

attracted jitterbugs, you'd likely hear swing tunes like "Little Brown Jug," "One O'Clock Jump" or "Beat Me Daddy Eight to the Bar."

Elsewhere, perhaps at a café with a jukebox or in a downtown hotel ballroom, you could catch the sweeter drift of an orchestra in an updated interpretation of something old—say, Stephen Foster's "Jeanie (With the Light Brown Hair)" or Victor Herbert's "Indian Summer."

You might have been strolling some evening along Swope Parkway or Troost when the open-air streetcar known as "The Scout" swooshed past, draped in strings of lights, with a crowd of sightseers and an on-board orchestra playing current favorites like "South of the Border," "Beer Barrel Polka" and "God Bless America." That's one you heard all over town, an old Irving Berlin tune that he had retooled with patriotic lyrics. Now, with the European war, "God Bless America" seemed to be everywhere. The Jenkins Music Company couldn't keep Kate Smith's recording of it in stock. One day, the Jenkins Company received a letter from a farmer in Iowa that suggested something about the song's popularity and the public mood: "Please send me phonograph records of 'God Bless America' and 'Let the Rest of the World Go By,'" he wrote. "That's how I feel about things."

Customers cast hundreds of ballots in Wolferman's weeklong music poll. Results showed that the top five songs were "Indian Summer," "Careless," "All the Things You Are," "South of the Border" and "Stardust"—all "sweet" tunes as it turned out, perhaps indicating that jitterbugs shopped elsewhere for good things to eat.

## 1500 Broadway

The man who owned the City Food Store at the corner of Fifteenth and Broadway, downstairs from the rooms of the Hotel San Dora, also owned three other City Food Stores—on East Eighth, East Twenty-fourth and East Thirty-first Streets. He was born a Russian Jew and grew up in St. Joseph, Missouri, and until the previous year, he had been known as Abe Trilinsky. The name was now Abe Trillin.

Kansas City was filled with food markets of all sizes and flavors. There were vegetable markets, fruit markets, dairy markets, butcher shops and kosher markets. Poultry markets, many just outside city limits, kept chickens in pens ("Alive until ordered. Dressed free.") and sold fryers, springs, roosters, hens, stews, turkeys, eggs and milk. There was the new City Market. There

## From Vacant Lot to Modern Architecture

City Food Store, 1500 Broadway.

were supermarkets. There were mom and pop groceries, sometimes clusters of them in a single block.

In the groceries, you found homegrown tomatoes sold by the peck basket, beef for boiling, Limburger cheese, tomato-kraut juice, beef hearts and tongues, puffed wheat, pure rendered lard, bags of soap chips, packages of water softener and jars of spiced pigs feet. Just about anything was available in cans, from prunes or spaghetti to fly spray or Spam ("All meat, no waste"). In the summer, you found fresh Texas watermelons, Arkansas peaches, Michigan celery, California lettuce, Arizona cantaloupes, Washington apricots and Colorado raspberries.

There were local markets with several outlets, such as Muehlebach's, Wolferman's, Milgram's ("Kansas City's Own Merchants") and associations of independents, like HGF stores ("Your Home Town Grocer"). The trend was moving away from small groceries that offered home delivery and toward self-service supermarkets operated by national chains like Safeway, Kroger and the Great Atlantic & Pacific Tea Company (A&P). Supermarkets often had their own parking lots and drew business from a wide area.

The City Food Stores were neighborhood markets, serving customers in surrounding blocks. The neighborhood around Fifteenth and Broadway, like

so many in Kansas City, was white working class. People were primarily renters, singles and families, old and young. Many adults had no more than eighth-grade educations, working as cooks, filling station attendants, carpenters, railroad switchmen, waitresses, elevator operators, firemen, mechanics and WPA road builders. Several Greek immigrants lived nearby.

The thirty-plus potential customers paying $3.50 for rooms in the Hotel San Dora were mostly single, middle-aged males, many divorced or widowed. They were drugstore clerks, firemen, mechanics, truck drivers and hotel employees.

Downstairs, Abe Trillin arrived six days a week from his produce-buying trip to the City Market. He arose each morning before dawn for the nine-mile drive to the market from a bungalow near the southern city limits where he lived with his wife, young daughter and son. He was thirty-three years old, a second-generation grocer who didn't smoke cigarettes or drink alcohol or coffee and who changed his name because he thought "Trillin" sounded more American.

He was known at the City Market as a good pitch player and at the City Food Stores as a caring boss who paid bills the day he received them, a thrifty, honest man who ran his business in keeping with the city ordinance prohibiting groceries from opening Sundays, even though many independent stores and one local chain had been ignoring it for years.

Privately, he cursed the chain supermarkets and disliked the grocery business. He hoped that his four-year-old son, Buddy, would one day find a different line of work.

## 419 Main Street

It seems possible that Abe Trillin played pitch with Joe Polito, who sold wholesale produce out of a storefront on the west side of the new City Market. Born Giusseppi Ippolito in Sicily fifty-five years earlier, Polito, wife Rose, a grown daughter and a son shared a house in the Northeast neighborhood. The son worked with his father here at the market.

The City Market's summer grand opening was a twenty-four-hour affair. The idea was to let people see the entire business day of the market, which began in the wee hours. The celebration started and ended at midnight. The first of nine bands began playing at 3:00 a.m., and the party climaxed with a big dance. There were bright lights and dancers in calico, drum-and-bugle

# From Vacant Lot to Modern Architecture

Joe Polito's wholesale market, 419 Main Street.

corps and city officials. Mayor Gage spoke. "We must plan adequately for the future," he said, "so that Kansas City can maintain its importance as a great food center built up over eighty years on the site of this new market."

The new million-dollar City Market was built on the rubble of the old one and its neighbor, the Victorian red brick city hall. Two years earlier, after the new thirty-story city hall opened downtown, the old one was demolished along with the market and its colorful awnings, where hucksters once selected produce to peddle from horse-drawn wagons out in the residential districts. The new market served a $25 million industry and distributed farm bounty throughout the Midwest.

The business day began when the first delivery trucks and the early out-of-town buyers—some from Omaha or Des Moines—pulled in around midnight. Local grocers and restaurant owners came before dawn, bargaining for aisle and table. The housewives arrived with the sun and wandered among stalls.

The market was separate from the nearby warehouses of the largest wholesalers, which had their own railroad sidings for loading crops purchased in the fields. The market's new storefronts were for local wholesalers like Joe Polito, who sold produce grown far and wide—Arkansas potatoes, California

oranges and Texas onions. The four concrete islands at the center were for farmers who sold their goods from stalls renting for twenty-five cents per day.

They included the woman who had hauled produce from her east-bottoms farm for twenty-three years and the truck farmer from Rosedale, Kansas, who arrived at midnight with his wife and two young children in a truck weighed down with their lettuce, rhubarb and asparagus. They usually sold out early, drove home and returned to the fields. After dark, they reloaded the truck and, after stealing a bit of sleep, did it all again.

The speakers at the grand opening included the president of the Real Estate Board. The market was "one of the city's finest assets," he said. Something that excited him was the modern development that the market was bringing to the city's original neighborhood. It meant that many old buildings would be coming down to make way for new business.

The *Star* called it "one of the most amazing transformations in the city's history." Encouraged by the new administration, businessmen in the area had driven the modernization—everything from demolishing antique buildings to removing the bricks and streetcar tracks from Independence Avenue, widening it to four smooth concrete lanes. Improved streets had attracted new filling stations to the neighborhood. A dozen new parking lots had replaced old buildings.

Maybe the finest addition was opposite Joe Polito's store: free parking for City Market patrons, in a spacious lot built by WPA labor. Motorists would have to put up with streetcar tracks on Main Street a while longer.

# 5447 Forest Avenue

Laundry billowed on a clothesline behind the home of Frank Lang at the corner of Fifty-fifth and Forest Avenue. Lang was the city's building commissioner and held the power to approve or deny building permits. The City Market was not the only new construction in town this year.

Although you could see several demolitions in progress—usually older structures making room for parking lots—several building projects were planned or underway. Besides City Market, they included a drive-in restaurant for a couple of sisters named Winstead, a community center in the North End Italian neighborhood, a thirty-two-lane bowling alley on the Country Club Plaza, an addition at General Hospital No. 2 (for blacks) and the largest A&P supermarket in the Kansas City area (with parking

# From Vacant Lot to Modern Architecture

The Lang home, 5447 Forest Avenue.

for eighty-one cars), on the former site of a church destroyed by fire on Halloween night 1939.

That was Community Church, formerly known as Linwood Boulevard Christian. The church had purchased a sloping lot at the corner of Forty-sixth and Main and planned to start anew. Reverend Burris Jenkins wanted a forward-looking design, as befit a progressive institution known for controversial innovations like movie nights and church-sponsored dances. The board hired a controversial, forward-looking man for the job, known to them as America's greatest architect.

"You have got to look back to be sure of that forward look, designed ten years in the future and yet completed in November," said the white-haired, seventy-three-year-old Frank Lloyd Wright upon first seeing the vacant lot. "We'll be doing things in this building that have never been done before...We haven't realized yet just how much the motor car represents the individual. But nowadays the procedure should be to start with the parking problem and then build up. That is what I shall do here."

Frank Lloyd Wright's design for Community Church included no steeple, no radiators, no pews, no windows and no basement. It did include parking for 150 cars, individual cushioned seats for 1,200 people, room for a

## Kansas City 1940

100-person orchestra, a motion picture screening system, radiant floor heat and a nighttime shaft of light projecting through the roof.

As drawn, the church would be built of steel and concrete and rest on a bed of crushed rock. The "floating foundation" was based on a similar design for Wright's Imperial Hotel in Tokyo, which withstood a massive earthquake on the day it opened in 1923.

"Until now Kansas City has not had a look-in on what is going on in the modern world," the architect said. "The church will be hated violently, which is a good sign. It will also be liked violently and finally understood and appreciated…I think we all agree that the world seems in need of religion today. I am trying to divest the church of some of its formality, give it a little more grace and beauty. Perhaps in that way we can help bring religion back. Not religion in the old sense, because, don't you agree, religion in the old sense seems to have failed?"

Enter Frank Lang, who, as it turned out, had the same middle name as the architect. Lang refused a building permit for Wright's design, as it failed to meet the 1927 building code. Lang's engineers didn't like the floating foundation, the radiant floor heat or the free-form walls. One said it looked as if Wright intended to "put up a circus tent or something; a mere shell of a building."

The architect was incensed. "It's a question whether these city officials are going to abide by the letter of an outdated building code or will permit it to be liberalized as a tool of progress," he said.

Newspapers called it the "battle of the Frank Lloyds." Wright's optimistic November completion date came and went. There was talk that the church should build somewhere beyond the city limits, maybe over in Johnson County, Kansas. By year's end, the floating foundation had given way to traditional footings. Frank Lloyd Wright and his church of tomorrow had been overruled by Frank Lloyd Lang and his code of yesteryear.

## Chapter 4
# From Clocks to Radios

*I like Kansas City. It's a good place to live. Rocks stick out of the ground and you have to look up and down to see things. Flowers grow easily and there's a lot of redbud in the spring. There are plenty of regular men and women who live here—men and women you like because you can be yourself with them.*
—Thomas Hart Benton

## 1016 Baltimore Street

You might have noticed the small ad in the *Kansas City Journal*:

*Correct Time*
*Free 24-Hour Service*

 A phone number was listed. If you had a dial telephone, you simply dialed that number. Otherwise, you waited for an operator to say, "Number please," and then you told her, "Grand…one-seven…four-oh." When someone picked up on the other end, you would hear a female voice, possibly with a slight southern accent, telling you about a restaurant or a car dealership or some other business and then indeed giving you the correct time, or "tam" if the voice belonged to one of the two owners of Time Service of Kansas City.

## Kansas City 1940

1016 Baltimore Building.

Mary Livingston and Marguerite Frommer were two young women from Texas who this year had begun this service on the sixth floor of the 1016 Baltimore Building. Before moving here, they had run a similar business in Dallas, which they still owned.

It was a franchise originated by another woman in Houston, starting with a single French telephone. The latest up-to-date equipment made it possible to answer multiple calls at once. In Houston, the female voice also provided the current temperature (in hot weather) and sports scores (in football season).

Here, six operators worked 'round the clock in four-hour shifts, taking as many as five thousand calls over twenty-four hours. Most calls came when people were rising or setting their alarm clocks, before 9:00 a.m. and after 10:00 p.m. If you wanted a wake-up call, they could provide it.

## From Clocks to Radios

The operators received training in voice control and diction. Miss Livingston said that she had found one of the most difficult words to pronounce correctly was the word "time."

Unlike a similar operation in New York City, which charged a nickel per call, this service was free. Revenue came from advertising, Operators read a brief bit of ad copy before giving the correct time. The Texas ladies planned a chain of Time Services across the Midwest.

"We expect to build slowly and with stability," said Miss Livingston.

## 401 East Twenty-second Street

The newspaper carrying the one-inch advertisement for Time Service of Kansas City was produced in a Mission-style factory building on the western slope of Hospital Hill. The *Kansas City Journal* was an evening newspaper that provided small competition for the *Star*.

Paid circulation of the *Journal* had climbed past 90,000 this year, an increase of about 12,000 over 1939. The *Star* and its morning *Times* each enjoyed paid circulations exceeding 300,000. The *Journal* was also physically smaller than its rival. Both were eight columns wide—about sixteen inches—but the *Star* was longer by two inches and thus able to fit more news and advertising on each page. The *Journal* had become flashier since 1938, when it was still called the *Journal-Post*. It had larger headlines in a sans-serif typeface, more photographs and an expanded Sunday comics section.

The *Journal* was known to favor the sensational, as with an unsourced, front-page series this year alleging the presence in town of a "fifth column" of Nazi sympathizers. After the series began, editors had to amend it with a note: "The great majority of Kansas Citians of German descent do not even know of the existence here of a 'fifth column' organization and certainly are not in sympathy with some of its policies."

The *Star* was a Republican newspaper; the *Journal* leaned Democratic. Days before voters rejected the Pendergast machine, the *Journal* revealed wishful thinking with its page-one headline: "Democratic Victory Seen/Poll Gives Majority of 13,800."

The *Star* had its own radio station on premises; the *Journal* had a working relationship with the weak, one-hundred-watt KCMO, broadcasting atop the Commerce Trust building downtown. *Journal* editor Orville McPherson

# Kansas City 1940

*Kansas City Journal* building, 401 East Twenty-second Street.

had a weekly radio show, which often provided copy for the paper, as it did on New Year's Day:

> *Of course, Kansas City must do all it can in 1940 to destroy its reputation for corrupt politics and bad government. Kansas City is overwhelmingly a Democratic city…These Democratic citizens have the power to erase the stigma of their city and their party.*

Another *Journal* staffer was heard on KCMO. John Cameron Swayze generated copy in a variety of ways, from his Ruppert Stadium interview with Lou Gehrig a year earlier to this summer's movie reviews. He also reported the news on radio, and in the fall, he became a full-time KCMO employee.

KCMO also had provided a career start to Swayze's co-worker Betsy Maxwell, once an advertising copywriter. Now she wrote an advice column for the *Journal*'s women's page, "Ask Hope Hudson." Often her advice was on affairs of the heart:

> *Because he's a neighbor, friendliness on your part needn't seem the least bit suspicious, if you're decorous about it. Ask him to teach you to dance, and if you already know how, then ask him to suggest some improvements. It's*

## From Clocks to Radios

*harmless enough to roll back the rugs and turn up the radio on a summer afternoon and take a turn or two with the boy across the street.*

Betsy Maxwell's own "boy across the street" was the man across the hall on the third floor of the *Journal* building, in the United Press news service office. He was Walter Cronkite, whom she had met a few years earlier when both worked at KCMO. Cronkite now was night editor at UP. When he got off work, he often handed UP wire news to his friend Swayze as they passed on the stairs.

When you tuned in to KCMO at 7:00 a.m. and heard, "Good morning—John Cameron Swayze here with news from the *Kansas City Journal* newsroom," you would not have known it was the result of a stairwell collaboration.

## 1302 Broadway

The filling station at the corner of Thirteenth and Broadway was typical of many Red Crown stations across the Midwest affiliated with the Standard Oil Company of Indiana: white brick with a red-tile roof. The name referred to both the roof and the gasoline dispensed from pumps topped with red-and-white crowns.

Red Crown was the regular brand; there was also a budget-priced grade, as well as a premium, high-octane ethyl. Standard Oil promised that Red Crown was "[h]igh in anti-knock and loaded with carefree, thrifty miles." The summer ad campaign claimed that motorists in a survey preferred Red Crown to other brands by a two-to-one margin.

As the ads declared, "Today's the day to join the millions of motorists whose theme song is 'Let's swing along with Standard!'"

If you swung in here for five gallons of ethyl, you would find Atlas tires and accessories, a window display of Simoniz car wax, free road maps, a clean restroom and a close-up view of the stark contrast in architecture next door: the curving roofline and Norman-Gothic stone façade of the Grace and Holy Trinity Episcopal Cathedral.

On a Saturday in March, an arrangement of ferns and calla lilies decorated the altar of Grace and Holy Trinity for the wedding of two twenty-four-year-old journalists, Walter Cronkite and Betsy Maxwell. The bride's white gown included a long train and the gold locket previously worn by two earlier brides who eventually became her grandmother and

# Kansas City 1940

Red Crown filling station, 1302 Broadway.

her mother. The ceremony was traditional, performed by Very Reverend Claude Willard Sprouse.

For four years, they had kept their courtship as quiet as possible; it violated employee policy of their respective employers, the *Journal* and United Press. They admitted that it had been love at first sight, from the time they both worked at KCMO. Shortly after they began dating, they teamed up on the air, reading a script she'd written for the Richard Hudnut cosmetics company:

> *Walter: Hello, Angel. What heaven did you drop from?*
> *Betsy: I'm not an angel.*
> *Walter: Well you look like an angel.*
> *Betsy: That's because I use Richard Hudnut.*

As Mr. and Mrs. Walter Cronkite, they resided in a four-room Locust Street apartment, just off Armour Boulevard in the Hyde Park neighborhood. Before setting up housekeeping, they took a honeymoon trip down to Texas and old Mexico. Perhaps, setting out from Grace and Holy Trinity, they first swung into Standard and topped off the tank with carefree miles.

## From Clocks to Radios

# 2747 Main Street

If you needed a new car for your honeymoon trip, or any other reason, you had choices. Perhaps on your way to work each day you passed the Reid-Ward Motor Company at Twenty-eighth and Main, where Packards were sold. Several other dealers were also located in this neighborhood: Greenlease LaSalle-Cadillac, Allied Chrysler Plymouth, Lawler-Nash, Simon-Wiles Buick and Armacost Studebaker. Maybe you were ready to become one of Kansas City's 100,000 car owners.

You saw them earlier this year at Municipal Auditorium, the new 1940 models in their shiny, streamlined glory: Fords, Chevrolets, Chryslers, Mercurys, Oldsmobiles, Plymouths, Lincoln-Zephyrs, Pontiacs, Dodges, Cadillacs, Buicks, Studebakers, Hudsons, LaSalles, Nashes, DeSotos and Packards.

Of course, it was the Safety Fair. In 1939, Kansas City had reduced its auto deaths 54 percent, and the fair's emphasis was on the display of reinforced frames, safety-glass windows, center-point steering, electric turn signals, sealed-beam headlights and other features that people might have credited for the city's national award for fewest traffic deaths. But who could ignore those whitewall tires, that chrome ashtray, the radio, the plush upholstery or the color of that touring sedan or that convertible coupe? Not you.

Reid-Ward Motor Company, 2747 Main Street.

# Kansas City 1940

Maybe you had picked up a Packard brochure. The Packard long had been the top of the line, a rich man's automobile—a twelve-cylinder, 160-horsepower dream. But the company had responded to hard times and, by upgrading its factory, put Packards within reach for members of the middle class. It even offered the latest option: air conditioning.

If you were thinking of driving in Kansas City, there were a few things to remember. You needed four licenses to operate a car legally here: two for your car and two as a driver—one each for state and city.

The citywide speed limit was twenty-five miles per hour, except along certain thoroughfares such as Independence and Gladstone Boulevards, where you could do thirty-five, and up to forty-five on limited stretches near the city limits. At night, the limit was twenty-five miles per hour everywhere. Police Chief Reed had his boys cracking down on speeders, sometimes literally. Police were also watching for malfunctioning equipment. One night, they stopped drivers at Fifteenth and Paseo and tested lights and brakes. Five out of about three hundred cars had passable lights.

You had to share the road. The Highway Engineers Association held its convention here this year. Speakers included an official from General Motors and another from the American Road Builders Association. They talked about traffic congestion. "The city is its own bottleneck," the road builder said. "To preserve its property values it needs a network of modern slabs connecting suburbs and homes to the business center. A thousand horse-and-buggy streets won't do that."

Of course, you could opt to buy an older car. Simon-Wiles advertised some bargains on its used lot, like a '36 Hudson sedan, with a radio, for $275. Armacost had a sale—there was a '37 blue Packard sedan with twenty-seven thousand miles, a radio and a heater for $495.

But then, just $867 would get you a modest but brand-new Packard business coupe. There was that brochure: "You'll encounter new pleasures that you didn't know belonged to motoring…you can't afford to put off owning one any longer…you'll never be quite satisfied until you own one."

One evening, on your way home from work, you might have decided that it was time to stop at Reid-Ward Motor Company for a test drive. It was time to ring the bell and get off that lumbering streetcar. It was time to enter the world of tomorrow.

### From Clocks to Radios

## 915 East Ninth Street

The so-called bottleneck of "horse-and-buggy" streets leading to downtown vexed motorists and business owners, but not everyone. These brick Victorian-era row houses on the south side of East Ninth between Harrison and Campbell were part of an eclectic neighborhood. Storefronts included a grocery, a poultry shop, a drugstore, a few taverns, a laundry, a cabinetmaker, repair shops for watches and shoes and several apartment hotels and rooming houses.

The old row houses contained furnished rooms. The resident landlady was Eva Murray, a fifty-nine-year-old widow whose tenants included a delivery boy, a bread wrapper, a cook, a maid, a waitress and a few WPA workers, all white. Black residents lived around the corner on Charlotte and on Tenth Street.

By some standards, it was a less than desirable neighborhood, and at least one observer suggested that it could be improved by widening the street to increase traffic and business. One of Eva Murray's tenants considered it to be just fine as it was, and he said so in a letter to the *Star*:

> *I do not subscribe to the theory that broad thoroughfares stimulate business along them. Bohemian life lolls along Ninth street because it is friendly. One*

Eva Murray's furnished rooms, 915 East Ninth Street.

*does not have to shout across the street to be heard, nor does one have to dash across to escape being hit by motor cars. Bohemians want their own quarter undisturbed by the hawkers of big business.*

His voice was drowned out by those complaining that downtown suffered from its grid of narrow, congested streets laid out in the nineteenth century. "We must have a modern system to utilize the full power of the motor car investment," the *Star* demanded. "It must be free to move fast, easily and safely."

The flow of traffic in the city was not a new concern. The desire for more trafficways had been around for decades, since the days when a "trafficway" was defined as any roadway that could carry delivery wagons across town on an easy grade. The city's natural obstructions—bluffs, hills and streams—made such trafficways a challenge, even as more autos and trucks filled the streets each year. New trafficways had been promised as part of the Ten-Year Plan of improvements approved by voters in 1931, but funds had been all but depleted by the greed of the Pendergast machine.

With reform government in city hall, traffic congestion became a renewed priority. New Southeast and Southwest trafficways topped the wish list, but not enough of the Ten-Year Plan money remained to build them. One evening, more than two hundred east side residents attended a meeting of the Twenty-seventh Street Improvement Association to vent frustration. As one man put it, "We are bottled up, our property is depreciating and we cannot reach our work or go downtown shopping without either traveling over terrible roads or going far out of our way to reach boulevards."

It was decided that remaining funds would be best used by improving existing streets and using cheap WPA labor. "Improving" meant widening and streamlining—multiple lanes with medial dividers, no left turns and no streetcar tracks. Improvements were begun along Prospect and Independence Avenues and then along Twenty-seventh Street.

The original design for new trafficways had called for roadways eighty feet wide, enough for several lanes of traffic plus curbside parking, and many people still wanted eighty feet, not the compromise forty. Not everyone agreed. At another public meeting, a woman stood up: "No mother wants to raise children on a trafficway," she said. "An eighty-foot trafficway would force the removal of many large trees along the street. Such a roadway would come right up to my steps."

### From Clocks to Radios

# 1912 Main Street

Robert H. Richardson thought that he had a solution to traffic congestion. He'd been reading the papers and had seen ideas for wider, faster, streetcar-free streets. The sixty-year-old owner of a mom and pop confectionery a few doors south of Boss Tom's Jackson Democratic Club, Richardson and his wife, Alma, lived across the street in the Midwest Hotel. Alma, three years older, also worked behind the store's counter.

The solution seemed clear to him, and he explained it in a letter to the *Star*. A week later, he brought his idea to the Little Theater in Municipal Auditorium for the Downtown Committee's town hall meeting about the traffic problem. The special guest was Dr. Miller McClintock, the Yale University traffic expert.

The nation's traffic problem, Dr. McClintock said, was the result of becoming "motorized" in a single generation. The problem was twofold, thirty thousand annual traffic deaths being the first. "On the other hand, we have a congestion condition that has resulted in the decentralization of cities, causing them to spread out with a loss of cohesion and efficiency."

Dr. McClintock took questions from the audience of more than two hundred people. Yes, he said, parking meters controlled congestion because they cut

Robert Richardson's candy store, 1912 Main Street.

# Kansas City 1940

down on double parking. No, he didn't care for the proposed Southeast and Southwest trafficways because they lacked modern engineering standards for safety and speed. Better to install medians and "no left turn" signs to give existing streets elements of true expressways. And yes, even the loveliest residential district, given sufficient right-of-way, could include an elevated expressway.

Robert Richardson summoned his courage and stood to present the idea he had outlined in his letter to the editor. "For a long time, I have had a pipe dream that a subway should be built from Seventh and Delaware streets to Marlborough," he said, referring to the suburb south of the city limits. "It could be done without moving any property and the nine-mile subway could be built for two million dollars, which could be paid from the cigarette tax. The subway would take two carlines off the streets and you could get downtown in fifteen minutes."

Dr. McClintock said he appreciated the enthusiasm but couldn't support the idea. Subways, he said, cost $3 million per mile; probably it would be difficult to wring $27 million out of the cigarette tax.

# 1204 Baltimore Street

Some dreams received more respect than others. Barney Allis dreamed about waves of automobiles flowing toward downtown along sleek, high-speed thoroughfares, unfettered by pedestrians, double-parked trucks, streetcars or traffic signals.

Allis, the Hotel Muehlebach's owner and resident manager, was an immigrant Polish Jew who ran what had become—with the demolition of the Hotel Baltimore and despite competition from the President, Phillips and Continental Hotels—the destination for traveling politicians and celebrities, as well as for locals out for a night of dining and dancing in the Terrace Grill. This year, for instance, the Muehlebach welcomed Ernest Hemingway and his bride of five days, in from Wyoming and still wearing cowboy boots.

Allis also was a member of the Downtown Committee, the group of businessmen seeking to steer the city away from its past. As vice-chairman of the subcommittee on trafficways and parking, he made the Muehlebach the site of his group's meetings.

One meeting, attended by almost one hundred members, solicited ideas for an improved downtown. One man thought it important to be known as a

## From Clocks to Radios

Hotel Muehlebach, 1204 Baltimore Street.

friendly city. Barney Allis had a bigger idea, which he revealed in a six-page outline. "No plans, no matter how fantastic, no matter how broad, no matter how much a dream, should be considered too great," he told them. "Kansas City must not be left high and dry." He called for a fifteen-year plan. Its centerpiece would do something about the painfully slow crawl of traffic in and out of downtown—something big.

It would be a super-express, north–south highway—eight lanes sweeping through the middle of town, from Forty-ninth or Fiftieth Street to Twentieth Street, with no access between. This would connect with an east–west artery on the southern end and on the north would encircle downtown twice: an inner loop and a larger outer loop. Wide, one-way streets would run within the loops.

# Kansas City 1940

To make room for this expressway, he said, the plan would condemn and demolish nearby slums. All property along Main from Third to Ninth and from Thirteenth to Twentieth would be demolished and cleared. It would create beautiful approaches with trees and shrubs. The city would issue bonds and secure government grants and loans to pay for it.

Barney Allis had either been to the New York World's Fair, then in its second and final season, or he had seen *To New Horizons*, the film General Motors produced for its Futurama exhibit at the fair. His idea spoke to that "World of Tomorrow." "The whole plan should be presented with a picture, a 'Futurama' of Kansas City," he said. "Let it be a dream, if you please."

Upstairs in their Muehlebach suite, the Hemingways waited to receive his friend Luis Quintanilla, a Spanish muralist who had moved to town. Hemingway passed the time by chatting with a newsman, recalling his days as a young reporter at the *Star*. The newsroom's rules for clear, accurate, concise writing were still fresh in his mind. "Those were the best rules I ever learned for the business of writing," he said. "I've never forgotten them."

And downstairs in the Terrace Grill, the past was similarly reliable. Most nights were filled with the venerable sweet music of orchestras led by Gus Arnheim, Little Jack Little, Joe Venuti or Ran Wilde. Guests danced to familiar tunes, perhaps concerned that the world of tomorrow would be more about Hitler than expressway loops.

# 5120 Rockhill Road

Working inside this hall on the campus of the University of Kansas City was the man whom Ernest Hemingway had called "one of the bravest men that I have ever known." He was Leon Gerardo Luis Quintanilla Isasi Cagigal Zerrageria, better known as Luis Quintanilla, a forty-seven-year-old Spanish muralist and the university's new artist-in-residence.

For the next year, he would bring an artist-apprentice style of teaching into play as he painted frescoes on the plaster walls of this Liberal Arts Building.

Quintanilla had known Hemingway since a 1922 meeting in a Paris bar, with the writer and the artist—"Ernesto" and "Luis"—getting drunk over stories of Spain and the bulls of Pamplona. In 1934, when Quintanilla was jailed in Madrid for harboring rebels trying to overthrow the Spanish government, Hemingway was among many worldwide who petitioned for his release, and he helped get a showing of his work in New York.

## From Clocks to Radios

Liberal Arts Building, University of Kansas City, 5120 Rockhill Road.

With the outbreak of the Spanish civil war two years later, Quintanilla led Loyalist attacks on General Franco's military, for which he earned a spot on Franco's execution list. He left the fighting but traveled about, drawing stark scenes of war and death, and with Hemingway's encouragement, he brought the work to the Museum of Modern Art. The *New York Times*' critic wrote, "No record of the war in Spain will outlast the incomparable drawings of Luis Quintanilla, the illustrious Spanish artist."

In 1939, when the Second Spanish Republic fell to Franco's army, Quintanilla became an exile in the United States. He brought his American wife and infant child with him to Kansas City, as well as an idea for the six-panel mural he would create on the walls of the Liberal Arts Building at the university. In his third-floor studio, he sketched studies. University students assisted and modeled for the frescoes. Other campus figures—a carpenter, a fireman, the night watchman and the head of the English department—posed for sketches. It would be an interpretation of an old story from his homeland, the story of Don Quixote—on these walls, a simple, honest man in the modern world.

In November, when Hemingway and his bride passed through town and entertained the Quintanillas in a suite at the Hotel Muehlebach, perhaps

# Kansas City 1940

they spoke of the Don Quixote project and its relevance to something Luis had expressed in a letter to his old friend Ernesto:

> *America has rejuvenated me, and pretty light of baggage I am beginning a new life and a new work. Between all the stupidity that is dominating the world, so much decadence of moral values, so much ideological gloom, I, like the snail, wish to close myself in the shell of my work, and in compensation make a gay art, an art that brightens existence as a toy entertains a child, and if the child breaks it—well, it is of no importance.*

## Brush Creek Boulevard and Oak Street

At the opening of the William Rockhill Nelson Gallery of Art and Atkins Museum in 1933, the *New York Times* pronounced it "one of the great art galleries of the world." It was no small honor for a midwestern town with a large, thriving stockyards and many citizens with rural sensibilities.

Seven years later, the Nelson was a place of varied and sundry activity. Not least was the announcement that it would be one of twenty-three

William Rockhill Nelson Gallery of Art and Atkins Museum, Brush Creek Boulevard and Oak Street.

## From Clocks to Radios

galleries to get a traveling exhibit of paintings by nine of the country's top artists, including the new artist-in-residence at the University of Kansas City, Luis Quintanilla; the Kansas City Art Institute's Thomas Hart Benton; and Benton's good friend from Iowa, Grant Wood. The paintings were the artists' interpretations of scenes from the new John Ford movie based on Eugene O'Neill's play *The Long Voyage Home*.

This year, the Nelson loaned its paintings to New York galleries for exhibitions of self-portraiture and of French classicism from the seventeenth and nineteenth centuries, as well as its pottery for a showing of Persian art. Among its purchases was *Virgin and Child*, a rare painting by the fourteenth-century Italian master Lorenzo Monaco.

There was an auction to raise funds for the Red Cross. Seventy-three artists donated works or commissions, and 250 patrons bid on them. The highest price paid was $175 for a commissioned painting, in oil or tempera, by Benton. The winning bid came from a stockbroker, who said that he wouldn't know the painting's subject until he discussed it with the artist.

And there were the gallery visitors, who could have been represented by a group of seven elementary school students and three adult chaperones from Bushong, Kansas. Their hundred-mile journey was made by train, and in addition to touring the gallery, they stopped at Liberty Memorial and Swope Park and ate supper in the Union Station Harvey House before returning home.

This year, field trippers got another destination to add to their sightseeing list. The Kansas City Museum moved from the basement of the downtown public library into its new home in the Northeast neighborhood—the former mansion of the late lumberman R.A. Long.

WPA artists and craftsmen built cabinets and researched, cleaned and restored many of sixty thousand artifacts. In the first month, sixteen thousand visitors from thirty states and one foreign country filed past the butterfly collections, Civil War and Indian relics, rare dolls, rare books, portraits of Kansas City pioneers, dinosaur bones, model trains and boats, bird eggs, a buffalo and other mounted wild game and fish, the largest meteorite to fall in the state of Missouri and two shrunken Inca heads.

The director of the William Rockhill Nelson Gallery and Atkins Museum was Paul Gardner. When the gallery was being built, Gardner, an architect himself, had advised the contractors and designed the benches in each gallery.

This year, Gardner, who was born in Boston and grew up in San Francisco, served as the juror for an exhibition of works by Texas artists, shown in San Antonio, Dallas and Houston. Here at home, his day-to-day duties included answering written inquiries like this one:

# Kansas City 1940

*I have a beautiful Hereford calf which has been mounted. It has two heads, four eyes and three ears. I will take $2,000 for it.*

Perhaps Gardner suggested to the owner that such an artifact would look splendid at the new Kansas City Museum, among the buffalo and the shrunken heads.

## 3616 Belleview Avenue

From his window this year, Thomas Hart Benton could see workmen swinging hammers on the new house that Frank Lloyd Wright had designed for the neighbors. Here, he entertained visiting friends, including fellow regionalists John Steuart Curry and Grant Wood. He ate and slept here, perhaps dreaming of a delicate grapevine in pencil or a farmland hailstorm in tempera. He played his harmonica here. It soothed his infant daughter, Jessie.

Here in his limestone house, he learned that he had made 1940's list of the nation's five best husbands—so said a group called the Divorce Reform League. "Too many husbands want to be the center of gravity in married life, with their wives revolving around them as so many unimportant and dependent satellites," said the league's director. Other good husbands were President Roosevelt and former Yankee great Lou Gehrig.

It had been a year since *Life* magazine sent Alfred Eisenstaedt to the Kansas City Art Institute to photograph Benton in his studio painting the nude *Persephone*, which critics found indecent; two years since he, Wood and Curry judged a costume party at the Art Institute, drinking, flirting with female students and awarding a case of whiskey for best costume to a young man in pajamas; four years since his mural in the Missouri Capitol scandalized those who had hoped for scenes of education, industry and Ozarks landscapes but instead got a brewery, sides of stockyards beef, Jesse James robbing a bank and Boss Tom Pendergast smoking a cigarette; and five years since he took the teaching job at the Art Institute, having returned to his native Missouri from New York.

This year, he created lithographs of the Joad family for a special edition of *The Grapes of Wrath*, John Steinbeck's year-old Pulitzer Prize winner, as well as for Twentieth Century Fox to use in promoting the film version.

Coincidentally, the Kansas City Board of Education had voted, four to two, to return Steinbeck's bestseller to library shelves after having banned it

## From Clocks to Radios

The Benton home, 3616 Belleview Avenue.

earlier. One of the two dissenting board members called the book "obscene, vulgar and indecent," adding, "The book is tainted with the filth, indecent stories and foul words of the brothel house. As spoiled grapes are discarded because they are rotten, so should foul books be kept from the library shelves when they are spoiled by the indecency of their contents."

Benton's response might have sounded something like the one he had for his Missouri mural critics. "I am an ordinary American painting the world in front of me," he said then. "I have no time for hocus-pocus."

He was not surprised at being named a best husband. He said that it took work to stay married eighteen years and that his wife deserved some credit. Rita Benton said that her husband didn't wash dishes or help with the cooking on the maid's night off. His pipe ashes fell on the rugs, and he hadn't changed a diaper since sticking their first child with a pin years earlier.

"I've got a system," he noted. "I leave my wife alone and she leaves me alone, and I always eat what she puts in front of me. Never kick about your wife's cooking."

"What kick have you got?" she asked. "What I want to know is, how do they know Tom is the best husband?"

# Kansas City 1940

## 1616 Wyoming Street

The erstwhile, wide-open Kansas City nightlife had been an inspiration for Benton, as he had claimed a few years earlier. The clubs provided plenty of grist for his work. "Not the dinner clothes spots," he said. "But the dumps in the stockyards are swell. And the north end is full of Sicilian life, not to mention the Negro dives, of which there are plenty."

Probably Benton's list of stockyards "dumps" included the Cowboy Inn, a joint with a streamlined façade in the shadow of the Livestock Exchange Building. The proprietor, fifty-seven-year-old Walter E. Hutchins, was a gambler with a reputation for being "a square John."

Back when the national press sometimes referred to Kansas City as the "amusement mecca for the cattle and wheat country," if you were a cattle buyer doing business in the big town, maybe set up overnight in the Drovers or the Victor or one of the other roughneck stockyards hotels, the Cowboy Inn was a convenient place to find a game. Hutchins would cover whatever amount you'd be willing to throw on his craps table, no questions asked. He made lots of friends, from stockyards laborers to bankers.

Several years earlier, Hutchins and a friend had operated a few pool halls in the West Bottoms. When the partner worked some business deals that

Cowboy Inn, 1616 Wyoming Street.

went sour, Hutchins told him, "If I didn't have any more sense than you have, I'd blow my brains out." Two days later, the friend shot and killed himself. The incident haunted Hutchins. Early this year, he told the friend's widow that he felt responsible. After that, he spent a few restless days in the Cowboy Inn, pacing. Then he locked his office door, took out a gun and put a bullet in his own head. He died at General Hospital.

No one knew for sure what demons or doubts pushed him over the edge. There was an illness of a few years, and friends said that he never got over his guilt for his partner's suicide. Maybe an artist like Benton could also wonder whether an old gambler ever really got over the loss of his crap game. "Say of him that he was a square gambler of the old school," said Hutchins's wife, Olive. "He always told me 'Our money has no home so let's play everything for the limit.' He had a million friends."

## Twenty-third and Wyoming Streets

Down the street from the Cowboy Inn and a cowpie's toss from the braying pens of the vast, malodorous stockyards, the American Royal building sat quiet and empty for much of every year. In its off-season, the building occasionally moonlighted for events like the Shrine Roller Derby, in which women in colorful uniforms skated and collided over an eighth-mile wooden oval track. Or it would be something like the pre-election political rally, with Thomas E. Dewey, the New York district attorney, filling the hall to rail against a Roosevelt third term, calling it "the most dangerous threat ever made against our liberties."

"America is not in the last stages of corrupted morals," Dewey told the crowd in late October. "They will prove it by electing a fresh, a new, an earnest administration headed by Wendell Willkie."

In November, after voters disappointed Dewey, the building showcased its main event: the forty-second annual American Royal Livestock and Horse Show. In small-town newspapers, bus companies advertised special excursion fares to "see the best there is in beef, cattle, swine, sheep, draft horses, mules, poultry," as well as "the country's finest harness and saddle horses, hunters and jumpers." There were industrial exhibits, government displays, high school bands and drum majorettes. Future Farmers and 4-H Clubbers convened.

Judges deliberated to choose award winners among four hundred horses and six thousand barnyard animals. Sixty-four girls from sixty-four small

## Kansas City 1940

American Royal Building, Twenty-third and Wyoming Streets.

towns competed to be named Queen of the American Royal. The queen, a nineteen-year-old from Tulsa, was crowned and kissed at the coronation ball by Master of Ceremonies Leo Carrillo, a character actor often seen in Hollywood westerns. Among the four-legged competitors, bedded down in stalls and pens, winners received blue ribbons. Some were purchased by Swift & Company and, after a final ride across the river to the company's stockyards plant, were displayed at a public open house as fresh cuts of dressed meat, complete with their prize ribbons.

Before that, there was the opening-day, three-mile downtown parade. Because of a cold drizzle, with six soggy floats carrying prospective queens in rain slickers and thousands of chilled spectators huddled under umbrellas along the route, it was the parade that almost wasn't.

But Leo Carrillo, doubling as grand marshal atop his favorite paint horse, said what only a Hollywood western character actor who had led a lot of parades would say in such a situation: "Let's hit her on the nose and go."

### From Clocks to Radios

## 558 Wabash Avenue

Horses were prominent in the American Royal, where the lumberman R.A. Long's daughter, Loula, still presented in the show ring every year, wearing spectacular hats and winning ribbons. She was a lifelong horse lover, as was Herbert Woolf, founder of Woolf Brothers clothing store. It had been just two years since his own thoroughbred, Lawrin, won the Kentucky Derby.

Although they could be found at the head of parades, it had been years since horses raced to fires, pulling wagons for the fire department, and longer still since Kansas City streetcars were horse-drawn. But as residents of the Stonewall Court Apartments could see from their covered porches in the Northeast neighborhood, horses had not entirely disappeared from the workday streetscape, despite forty years of the internal combustion engine.

Chief of Police L.B. Reed wanted to bring back mounted patrols for the downtown area. The department had last used horses in 1929, but the chief asked the board of police commissioners to make room in the budget for the purchase of twelve steeds. Reed believed that mounted officers were more efficient for working parades and the occasional riot.

A team of draft horses had been seen dragging a plow around a vacant lot in the Roanoke neighborhood, creating a graded access for a steam

Stonewall Court Apartments, 558 Wabash Avenue.

shovel to prepare the site of a Frank Lloyd Wright–designed house. A few horses still pulled delivery wagons. Horses were still bought and sold down in the stockyards. And come Christmastime, an advertisement appeared in the *Star* that read, "Horses fed free Christmas dinner 915 East Fifth." This meant that any horse past his prime or down on his luck would get a Yuletide reward, courtesy of the late Emma A. Robinson.

Mrs. Robinson, who had founded a kindness-to-animals organization, served the dinner herself for years before she died in 1932. In her will, she bequeathed ten thousand dollars for an annual "horses' Christmas dinner"—a bushel of oats or a half bushel of corn chops for each diner. "We give them more if their ribs are sticking out and they look awfully hungry," said the woman in charge.

## 1305 Park Avenue

The city's pet population included at least one pony, which somehow escaped from its backyard pen on Cypress Avenue and wandered four miles to State Line Road. But veterinarians guessed that about thirty-five thousand dogs lived in Kansas City. Two of them lived at this address, where Anthony Manger ran a radio repair shop out of his rented house. It was a neighborhood where everyone was white and worked hard. They were truck drivers, firemen, factory workers, WPA laborers, wives and children.

A radio repairman worked on all kinds of radios, stocked parts and tubes and made fifty-cent service calls, days, nights and Sundays. Manger and his wife, Lucille, had no kids, but they did have a white kitten and the two dogs, Punky and Toby. Other dogs lived nearby, including Rex, Queen, Trigger, Petey, Pigs, Jiggs and Prince. Beyond were Bing, Cricket, Taffy, Otto, Davey, Toots and countless others.

The fee for a city license was $1.50 for a male dog and $3.00 for a female, prices out of reach for working-class families. A city ordinance targeted owners of dogs who barked incessantly, but there was no leash law. So dogs—licensed and unlicensed—roamed free. Some got into trash cans and dug up gardens, some bit people and some became lost dogs.

The city had two dogcatchers and one old, beat-up truck. If a dog had no tags and was luckless enough to be rounded up, he went to the pound down by the Missouri River. There was a small shed under the Hannibal Bridge,

## From Clocks to Radios

The Manger home, 1305 Park Avenue.

a forty- by forty-foot slab of concrete with no shade. If no one called for the dog within three days, it was poisoned with strychnine.

Someone else was poisoning dogs in the Thirteenth and Park neighborhood, more than forty of them. The dog owners looked accusingly at anyone who had ever shooed a dog out of a flower garden. They also began tying up their pets.

It was too late for Rex and Queen. Pigs, known for fetching newspapers and carrying packages, was also gone. Small boys pointed and told friends which house was where Jiggs used to live. At the Manger house, Toby and the white kitten were force-fed milk and lard to dilute the poison, but Punky died.

Anthony Manger was angry, and he would not be intimidated. He had grown up on the North Side, the neighborhood once run by Johnny Lazia before he became Pendergast's henchman. Manger (born Mangiaracina) came from a tough Sicilian family. His younger brother had a history of arrests on liquor and narcotics charges. Years earlier, another Mangiaracina, perhaps a cousin, had been hanged for murdering a cop during the 1928 Republican convention in town.

Whoever killed Punky was asking for trouble. Manger said that if he knew who it was, he wouldn't bother to call police. "When I got through with him he'd be calling the police himself, if he was able," he said.

# Kansas City 1940

## 1729 Grand Avenue

The twin towers of radio station WDAF loomed over the *Kansas City Star* building at Eighteenth and Grand. The *Star* had owned the station since 1922, and this year it dedicated new studios in the building, with room for an audience of two hundred. That's how many attended the opening-night, in-studio performance of the eighty-five-piece Kansas City Philharmonic, broadcast nationally over NBC.

The same number showed up a few days later for the debut of *Barrel of Fun*, a quiz program in which city dwellers tried to answer questions sent in by farmers. The first question was, "How many stomachs has a cow?" No one knew.

Each day, the *Star* published listings for programs on the air, from *Farm Service Hour* at dawn to European war news just before midnight. You could turn the dial to find *Bright Idea Club*, *Kitchen Kapers*, *Radio Airplane Trip*, *Range Riders*, *Amos 'n' Andy*, *Jungle Jim*, *The Lone Ranger* and *The Shadow*. There were variety shows hosted by Fred Allen, Jack Benny, Don Ameche and Kate Smith; game shows like *What's My Name?* and *Quiz Kids*; religious programs such as *Morning Bible Lesson* and *Hymns of All Churches*; countless showcases for all types of music but especially dance bands; and, of course, news, weather and sports.

*Kansas City Star* building, 1729 Grand Avenue.

### From Clocks to Radios

Besides WDAF, the *Star*'s program listings included stations WREN, KMBC, WHB, KITE and KCKN but sometimes not KCMO, which had a working association with the *Kansas City Journal*.

On Saturday, June 15, at 7:15 p.m., when you pulled up in front of your Emerson, Philco, Zenith, RCA or Stromberg-Carlson, WREN was presenting country music on *National Barn Dance*. Over on KMBC, it was the popular *Your Hit Parade*. WHB had Juanita's Rhumba Band live from the Southern Mansion restaurant downtown. WDAF offered fifteen minutes of Colonel Charles A. Lindbergh delivering another of his antiwar messages, "Our Drift Toward War." The news this week had Nazi troops marching into Paris, and the speech was timely.

Lindbergh, the famous flier turned leader of the America First movement, had been speaking out against American involvement in the European war. He disliked President Roosevelt and distrusted his leadership. His critics, in turn, found Lindbergh suspect because of past associations with Nazi Germany. A few years earlier, he had received a medal from Hermann Goering, commander of the German Luftwaffe.

On WDAF, the *Gordon Jenkins and His Music* program ended, and the voice of Colonel Lindbergh in Washington crackled across the airwaves. "I have asked to speak to you again tonight," he began, "because I believe that we, in America, are drifting toward a position of far greater seriousness to our future than even this present war." He noted that an organized minority was responsible for war propaganda in this country and that Americans had to act now to stop it, concluding:

> *Now that we have become one of the world's greatest nations, shall we throw away the independent American destiny which our forefathers gave their lives to win? Shall we submerge our future in the endless wars of the old world? Or shall we build our own defenses and leave European war to European countries?*

At 7:30 p.m., the NBC Radio Symphony took over. You were urged to stay tuned to WDAF for the *Grand Ole Opry*.

CHAPTER 5
# From Barbecue to Brimstone

*New Orleans might have been the birthplace of jazz, but Kansas City is where it grew up. And the same goes for Negro league baseball, which started on the East Coast but came of age in K.C.*

—*Buck O'Neil*

## 1900 HIGHLAND AVENUE

You could eat a fine meal at the Southern Mansion, the Westport Room, Nance's, the Savoy Grill or Jim Lee's downtown. You could go exotic at Italian Gardens. You could grab simpler fare at cafés like Price's or the Toddle House or at cafeterias like Myron Green's, the Forum or the Blue Bird. Chicken dinners were most popular beyond the city limits at the White House Open Air Gardens, Tootie's Club Mayfair, the Harrison Chicken Dinner Farm, the Green Parrot, Stroud's and the Old Plantation. Otherwise, it was a town of quick-lunch counters, hamburger joints and barbecue stands.

The oak and hickory wood smoke wafting from the metal stovepipe at the corner of Nineteenth and Highland was considerably more fragrant—and presumably less objectionable—than coal smoke from, say, a laundry or a train locomotive. According to customers, this corner—a few blocks from the intersection of Eighteenth and Vine and steps from the musicians'

# Kansas City 1940

Perry's Barbecue, 1900 Highland Avenue.

union hall, where Charlie Parker and Dizzy Gillespie met this year—was where the "Barbecue King" ruled the land of smoked meats.

It was a land that included the Tennessee ("Barbecued meats of all kinds"), the White Front ("Southern style barbecue, cold beer and pop") and the Blackhawk ("Noted for its tenderized meats with blended flavors"). There was the Starlight barbecue, the Old Southern Pit barbecue and the Kentucky barbecue, not to be confused with the Ol' Kentuck barbecue. And there was Perry's.

For thirty-two years, Henry Perry had been serving barbecue across lines of class and race. "Cooking for the people of Kansas City has taught me a lot," he said. "I have made lots of money and I've made lots of friends, ranging from humble to members of the moneyed groups."

Those friendships were rooted in those first days after he arrived from Arkansas, when he was a saloon porter on the bluffs of the West Side. They followed him to his first stand on Bank Street in the Garment District to the longtime joint at Eighteenth and Lydia and, finally, to this corner, a bone's throw from the jazz musicians' union hall.

Perry had been working in kitchens since he was fifteen, first in his native Shelby County, Tennessee, then cooking for crews aboard riverboats

steaming up and down the Mississippi. His menu offered not only chicken, pork and beef but also raccoon, 'possum and woodchuck: two bits for hot, smoked meat, served in newspaper, peppery sauce if you pleased. One day each year, he gave away his barbecue in sandwiches free to old folks and young, as well as to those who couldn't pay.

This year, at age sixty-six, the King of Barbecue died. Death arrived the first day of spring, at General Hospital No. 2, from complications of syphilis, a longtime ailment. Henry Perry's smoky art would move four blocks east and live on through two men who had been his employees. Charlie Bryant's barbecue opened later this year at Eighteenth and Euclid, run by Charlie and his brother, Arthur.

# 3210 Troost Avenue

The Blue Bird Cafeteria, downstairs from the Spaulding Commercial College, was run by Nelle Putsch and her husband, William, both in their fifties. It was a short streetcar ride from their home at Forty-third and Harrison.

The Putsches had owned the Blue Bird since moving here from Marshall, Missouri, in 1924. Their son, Justus (known as "Jud"), had helped out at the cafeteria during his years at Westport High School. Graduating from the University of Missouri, Jud left for New York City and a place in the executive-training program at R.H. Macy & Company.

The Blue Bird Cafeteria was a three-minute walk from the Westover Building at Thirty-first and Troost, headquarters of the South Central Business Association. The SCBA held its weekly lunch meetings in the Blue Bird's banquet room.

For twenty years, the SCBA had concerned itself with all things business around Thirty-first and Troost. For instance, the issue of black residents living south of Twenty-sixth Street came up in a meeting at the Blue Bird in 1938. Restrictive covenants had made it illegal, and for a time, courts upheld the restrictions. One founding SCBA member called that "a great victory for our district."

This year, a topic of great interest here, as it was downtown, was traffic. The proposed Southeast trafficway would run through this district, but an early plan showed it crossing Troost in an underpass without access to the avenue. Members opposed the plan. There was great resentment of

# Kansas City 1940

Blue Bird Cafeteria, 3210 Troost Avenue.

downtown interests who were driving the trafficway campaign; they seemed cold to business in outlying districts.

Traffic on Thirty-first also received attention, as it was one of the city's primary east–west arteries and central to the SCBA area. The consensus was that Thirty-first was too important to be burdened with lumbering streetcars and poor pavement. Members presented this case to city councilmen, as well as to City Manager L.P. Cookingham and Powell Groner of the Kansas City Public Service Company. The problem, Groner told them, was that the Thirty-first Street carline was one of the city's busiest. For the time being, tracks and pavement would be upgraded.

In general, it was a good year for the SCBA. The city's first J.C. Penney store opened on Troost, the area's largest A&P supermarket was built on Linwood, the Katz Drug Company built a new store where the Ormond Hotel had been demolished and a new lot for free parking could handle more than one thousand automobiles daily. No doubt downtowners looked on with envy and frustration.

But Nelle Putsch died suddenly at St. Luke's Hospital, a victim of acute pancreatitis. Her will left the Blue Bird to her son, and Jud Putsch returned home with his wife, Virginia, to take over the family business. For nine years,

he had been building a career in merchandising with one of the country's most famous retailers, and now he was running a small cafeteria on Troost Avenue.

Jud remembered the work he put in there as a boy, and he held no love for the restaurant business. In the fall, however, he moved the Blue Bird across Troost into a larger, more modern space. It was a fresh start.

## Twenty-seventh Street and Troost Avenue

If you were a reader of the *Star*, your search for an apartment or a house began at Thirty-first and Troost. The daily newspapers arranged classified real estate ads by geographical location, and the *Star* listings fell east, north, west or south of that corner. The *Journal* shifted the starting point four blocks north. For some people, a home's location with respect to Twenty-seventh and Troost was a more reliable indicator of desirability.

Twenty-seventh was to become the primary piece of the planned Southeast trafficway, perhaps six lanes wide from near Union Station east to U.S. Highway 40 near Raytown Road. Troost was the city's longest continuous street, stretching from First Street to Eighty-fifth Street. It carried the city's busiest streetcar line.

The intersection's four corners were occupied by two filling stations—a Standard and a Socony-Vacuum—the two-story Alana Apartment Hotel and the Barclay Apartments building. Nearby were a bowling alley; a movie theater; various shops, offices, bars and cafés; and flats, rooming houses, apartment buildings and private homes.

The five-story Barclay Apartments, home to more than two hundred residents, dominated the corner. It housed families and singles, several widowed or divorced. A scattering had at least four years of college. Six-month-old Donald Lauer was the youngest; he lived with his twenty-two-year-old mom and twenty-one-year-old dad, a sorter in a bottle factory. The oldest, Josephine Goldberg, was ninety-one, a widowed German immigrant living with her son's family. The son sold real estate.

The rest were nurses, railroad workers, department store saleswomen, stenographers, truck drivers, switchboard operators, streetcar motormen, WPA laborers, bookkeepers, mechanics, bartenders, cashiers, photographers, waitresses and traveling salesmen.

Elizabeth Briscoe lived in apartment 214. She owned the Bagdad Confectionary in the next block of Troost. Clarence Michaels up in 415

# Kansas City 1940

The intersection of Twenty-seventh Street and Troost Avenue.

was a police sergeant. In 301 was Beulah Pillstrom, a sausage packer at the Swift plant in the stockyards. George Weiserin in 306 was a radio musician at WDAF. Vernon Lane in 329 ran both Lane's Standard service station and the Alana Cab Company, across the street on the corner.

Lex Grant, twenty-four, lived in the basement of the Barclay building with his twenty-two-year-old wife, Lee, and three small sons under three. The youngest had been born the previous year, a year Lee worked forty weeks as a maid in a private home. Lex worked all fifty-two weeks as the Barclay's janitor. Together they earned $880.

The Grants were the only black residents in the building. They were among a handful along this stretch of Troost, but they needed to walk only one block north and two blocks east to find the creeping edge of the housing frontier. There resided several members of their race who weren't required to work as janitors to live among whites. In the *Journal*, those were homes "North of Twenty-seventh, East of Troost."

## From Barbecue to Brimstone

# 2600 Tracy Avenue

One block north and two blocks east of Twenty-seventh and Troost, in the block bordered by Twenty-fifth, Twenty-sixth, Forest and Tracy, the color line ran down the backyard alley. Whites lived on Forest and blacks on Tracy.

South of Twenty-sixth, like a black finger on a white map, the first five houses on the west side of Tracy were rented by black families. The home at the southwest corner of Twenty-sixth and Tracy was the home of Reverend Raymond Jordan and his wife, Sophia. Reverend Jordan was pastor of the city's largest church, St. Stephen Baptist.

Two years earlier, the Jordans and their black neighbors on Tracy had found themselves on the wrong end of an appeals court ruling that upheld an old racial covenant, a decision praised by the South Central Business Association. But the ruling did not stand, and in 1940, the racial makeup of the block remained unchanged. The Jordans and the white antagonists were still there.

Racial tension was familiar to this neighborhood. In 1922, a doctor's house around the corner was dynamited three times in one summer. Intimidation could be more subtle but just as clear: "Whites only." The problem was that housing north of Twenty-sixth—long identified as the black section—was limited. Houses and apartments were overcrowded,

The Jordan home, 2600 Tracy Avenue.

many with multiple families, as a result of years of ideology and official policy. Forty years earlier, although other forms of segregation existed, blacks and whites had lived in mixed neighborhoods.

As black families migrated north after the world war and Kansas City's population grew, real estate brokers began a campaign to keep neighborhoods pure. The "Negro" was bad for property values, they warned, and must be excluded for a neighborhood to be desirable. One early housing study talked of the "shiftless, indolent and lazy" blacks and the "unsanitary condition of the streets and alleys in the Negro districts" owing to the "ignorance and carelessness of the Negro."

These attitudes were already in place when President Roosevelt's New Deal institutionalized them. The Federal Housing Authority had made it official: neighborhoods weren't stable unless they comprised one racial and social class, and mortgages would not be insured in places without restrictive covenants.

Since 1925, fewer than fifteen new houses had been built for blacks in Kansas City, compared with thousands in white neighborhoods—especially J.C. Nichols's Country Club District. If you couldn't get a mortgage, you rented, and if you were restricted to living in a confined area, you took what you could find, often a shared room in a shared house. Overcrowding hastened deterioration. Systems failed, plumbing backed up, the roof leaked, paint peeled and the porch steps rotted. Because of high demand, a white landlord could charge high rents whether he maintained his property or not. If he didn't, soon enough a neighborhood had become a slum, and the real estate man could have his say about black residents and property values.

As the number of black citizens rose in the 1930s, the city's overall population actually declined as whites moved beyond the city limits. By 1940, civic leaders were worried, especially after hearing a planning consultant tell them that the "whole financial structure of cities, as well as the investments of countless individuals and business firms is in jeopardy because of something called 'decentralization.'"

Every so often, a newspaper advertisement would announce that a commercial building or a residential block had become "Open to Colored," with rents typically higher than what the previous white occupants had paid. With one such "opening" this year, editors at the *Call* had had enough. "No more self-serving lie was ever told than that 'Negroes cheapen property,'" they wrote. "When the crowding which prevails now and has always existed causes some Negroes to enter this new block, to meet the exorbitant rents they will live two to a house, which means that a new slum area will be in the making. The community is responsible for that."

## From Barbecue to Brimstone

# 1512 Paseo Boulevard

The Fountain View, overlooking the fountain at Fifteenth and Paseo, was an overcrowded apartment building. It contained five units and thirty residents. One apartment belonged to Quincy J. Gilmore, age fifty-eight, and his wife, Alberta, forty-two. The Gilmores had taken in six lodgers, all service workers, including a young married couple and a man in his late sixties. Still, they somehow found room for visiting friends, one known as the greatest tap dancer in the world: Bill "Bojangles" Robinson and his wife stayed here with the Gilmores several days in March.

Celebrity tap dancers were no strangers to the neighborhood. The Nicholas Brothers of Cotton Club fame, heading west this year from Broadway to Hollywood, stayed with friends at Twenty-fourth and Brooklyn. When Fayard, the elder Nicholas, was born, Bill Robinson had been performing for thirty years. In 1939, Bojangles celebrated his sixty-first birthday by tap-dancing a mile down Broadway, backward.

He was in Kansas City headlining *The Hot Mikado*, a wild, jazzy version of the Gilbert and Sullivan operetta. It was already a hit on Broadway and at the New York World's Fair and was due for a long weekend at the Music Hall. The Robinsons dropped their bags and sat down to Alberta Gilmore's

The Fountain View Apartments, 1512 Paseo Boulevard.

steak with lyonnaise potatoes and ice cream. Around the neighborhood, Quincy Gilmore might have been as famous as his light-footed guest.

Gilmore was the longtime business manager and traveling secretary for the Kansas City Monarchs—the players called him "Sec"—and was responsible for the team's publicity and connection to the community. Every year, he put together events for the Monarchs, including opening day, with its parade of marching bands; cars carrying reporters, team officials and ballplayers; and a police motorcycle escort.

Beyond, he had sponsored bicycle races on the Paseo, organized tourist excursions by boat and train and worked as an undertaker, a detective and a nightclub owner. During the Monarchs' off-season, he was business manager at the General Hospital No. 2. He belonged to the Elks Club and ran a pool hall known as the Elks Rest in the Lincoln Building at Eighteenth and Vine.

Sec and Bojangles pushed away from the remnants of their steak dinner and headed over to shoot pool. The weekend ahead would bring a private tap-dancing performance by a local boy, eleven-year-old Elroy Peace Jr., who had been performing regionally since winning an amateur contest at age six. Robinson would praise his technique, telling him, "You are master of what you are doing. Keep up the work."

And there would be the singing moon and erupting volcanoes, the jitterbugging girls and boys of the Music Hall, with a white audience in the orchestra section, a black audience in the balcony and the star of the show in a gold suit trimmed in ermine and a diamond-studded derby. "Bojangles brings down the house, as the saying goes," a *Journal* reviewer would write. "He is a sensational, sizzling 'Hot Mikado' and ranks high on the 'must see' list of every musical devotee."

But first there was the billiard table at Eighteenth and Vine. Word traveled quickly that Bojangles was in town, and people jammed the sidewalk and traffic knotted the street.

## 2128 Brooklyn Avenue

For years, the ballpark at the corner of Twenty-second and Brooklyn was known as Muehlebach Field. Now it carried the name of the man who, until he died in 1939, owned the New York Yankees and their minor-league affiliate, the Kansas City Blues: Colonel Jacob Ruppert. Ruppert Stadium was home to both the American Association Blues and the

# From Barbecue to Brimstone

Ruppert Stadium, 2128 Brooklyn Avenue.

Monarchs of the Negro American League. The previous season, both teams had won league pennants.

The Blues began this year by losing their star player: center fielder Vince DiMaggio, to the major leagues. They retained their outstanding young infield: first baseman Johnny Sturm, second baseman Jerry Priddy, third baseman Billy Hitchcock and shortstop Phil Rizzuto.

The Monarchs were led by left fielder Turkey Stearnes, first baseman Buck O'Neil, pitcher Hilton Smith and, after his late-season call-up, pitcher Satchel Paige. At the home opener, after the parade, flag-raising, comedian and three bands, and after Mayor Gage threw out the first ball, the Monarchs took a double-header from Memphis. Buck O'Neil went four for six with four runs batted in.

Opening day for the Blues was a success, too, with a trophy for best first-game attendance (16,549) and a victory over Columbus. Jerry Priddy homered and won a case of beer from Milton's Tap Room on Troost.

Walt Lochman broadcast Blues games over radio stations WREN and KCKN, brought to you by Mobilgas. A reserved seat cost eighty cents, two bits for kids. Bleachers went for forty cents. Black fans had to sit in the bleachers at Blues games; whites could sit anywhere to watch the Monarchs play.

# Kansas City 1940

By virtue of holding first place at midseason, the Blues were hosts for the American Association all-star game. A record crowd of more than eighteen thousand saw a team of league all-stars beat the Blues, 5–3. Priddy homered again—more beer.

The Monarchs' season included special events planned by business manager Quincy Gilmore. There was the second-annual Bathing Beauty contest, wherein forty contestants in swimsuits competed to win a loving cup, fifty dollars and the title of Miss Monarch 1940. There was a jitterbug contest between games of a double-header, won by an eight-year-old girl and her eleven-year-old celebrity partner, Elroy Peace Jr. They won fifteen dollars.

By September, the Blues had set a league record for double plays and clinched their second consecutive pennant. The top four American Association teams made the playoffs; the winner would play their International League counterpart in the Junior World Series.

The Blues took four of six from Minneapolis in the first round. Then the team the *Journal* called the "Blue Streak, finest piece of baseball machinery in the minor leagues," lost four of six to Louisville, the regular-season fourth-place finisher. Adding injury to insult, the Yankees called up Rizzuto and Priddy after the season.

The Negro American season was split into two halves, and the Monarchs again won both. That made eight pennants and one World Series in twenty-one seasons. (A Negro World Series had not been played since 1927.) As Gilmore said, "No other concern made up of colored members in the city or even the state of Missouri is as well known as the Kansas City Monarchs."

With the season over, they began touring and playing exhibitions against white minor leaguers and all-star teams of major leaguers. It had been seventeen years—the year their shared ballpark was built—since the Monarchs and Blues last played each other. In that six-game series, the Monarchs won five.

# 235 Ward Parkway

The ten-story Locarno Apartments, along with the neighboring Riviera, Villa Serena, Biarritz and Casa Loma, was the kind of place you lived if you were a well-off couple in your forties, fifties or sixties, enjoying the fruits of a successful career.

## From Barbecue to Brimstone

Locarno Apartments, 235 Ward Parkway.

You were probably a company executive, a business owner or other professional. You might have seen the ads for these buildings in the society magazine, the *Independent*, promoting the convenience and cost benefits of living here ("Host to the Discriminating—for gracious and abundant living"), with spacious rooms, electric kitchens and proximity to the Country Club Plaza.

Your neighbors were people like bookseller Bennett Schneider, Chevrolet dealer Isadore Feld, clothier Alfred Rothschild, Rabbi Samuel Mayerberg and eighty-two-year-old banker and Blues fan Edward F. Swinney, whose distinguished résumé was long and colorful.

Swinney was chairman of the First National Bank, where he had begun working as a cashier sixty-three years earlier. He was president of the bank for twenty-seven years. Formerly, he had been president of the American

# Kansas City 1940

Bankers Association, advisor to the Federal Reserve Bank, treasurer of the American Hereford Association, treasurer of the Kansas City Board of Education and board member of several companies. He had worked behind the scenes to help build Union Station, bring a Federal Reserve branch to Kansas City and rebuild the city's streetcar system. An elementary school was named for him.

Long ago, Swinney had befriended the widow and family of the outlaw Jesse James. Swinney and his wife, Ida, once lived in the Hyde Park neighborhood, not far from the home of Zerelda James. In 1898, when her son, Jesse Jr., was arrested and charged in a train robbery near Leeds, Swinney posted bond and testified to the boy's good character. Two years later, he served as a pallbearer at Zerelda James's funeral.

Another longtime friend was Judge Kenesaw Mountain Landis of Chicago, the commissioner of baseball. Landis, a former federal judge, first made his mark by fining John D. Rockefeller's Standard Oil Company $29 million for antitrust violations, then by making life hard for bootleggers during prohibition and, most famously, by banning Shoeless Joe Jackson and seven Chicago White Sox teammates from professional baseball for conspiring to lose the 1919 World Series.

In 1939, Swinney's wife died, ten years after a fall left her a semi-invalid. He still kept office hours, but now he spent more time on his farm near Excelsior Springs and at Ruppert Stadium watching the Blues.

This year, Commissioner Landis flew into town on TWA a few times to visit his friend and see some baseball. Over the years, they had attended many games together. They were in the stands for the Blues' opening day, and in July, they went to the American Association all-star game.

The all-star game was played on a warm evening, the day after President Roosevelt's renomination erased any remaining doubts that he would seek a third term. Fans carried jugs of ice water and portable radios the size of toolboxes; one guy brought his own beer packed in dry ice.

It was standing room only; people were perched atop the outfield billboards. If you could have, you might have chosen a seat behind Mayor Gage, sitting in the first base box seats with his college buddy Alf Landon, former governor of Kansas. Or you might have preferred a third base box near Swinney, with the bald head and kind eyes, sitting next to Landis, with his cigar and shock of white hair, resting his chin on the railing.

You might have dreamed of eavesdropping on those two, hoping for snippets between pitches about the relative merits of Jesse James, John D. Rockefeller and Shoeless Joe Jackson.

# From Barbecue to Brimstone

# 4348 Locust Street

Across Brush Creek from the Locarno Apartments, next to the J.C. Nichols Company offices, was the shop of an interior decorator who advertised in the local society magazine, the *Independent*:

> *Room-size Victorian needlepoint rug. Needlepoint pieces for chairs. Beautiful Aubusson rug. Lucy Drage, Inc. 320 Ward Parkway.*

Lucy Drage shared her Locust Street cottage near the Nelson with her friend Mary Firth. Clients of her Country Club Plaza shop lived in the city's grandest and most gracious homes. Once upon a time, she had lived among them.

The daughter of a successful grain broker, the sixty-four-year-old Mrs. Drage had grown up in style on Quality Hill, where neighborhood friends included Alexander Woollcott, who had since found literary fame with *The New Yorker* magazine and as a sometimes caustic drama critic for the *New York Times* and the *New York World*. Lucy's own fame was primarily local, although Woollcott once described her beauty by citing a few Broadway actresses, calling one an "eyesore" and the other a "frump" by comparison. Forty years earlier, she had been Belle of the Century Ball. She was said to have been the first woman in Kansas City society to smoke in public.

The Drage home, 4348 Locust Street.

# Kansas City 1940

Lucy married Colonel Francis B. Drage, an Englishman and an officer in the Royal Horse Guards. After ten years in England, the Drages built a huge second home here on thirteen acres at Seventy-fifth and Indiana, and she assumed management of her father's farm south of town. Colonel Drage died in 1935, having exhausted Lucy's large inheritance as well as their marriage. She now worked for a living, making the most of her fine taste and a business loan from her son-in-law.

Freddy Harvey, grandson of the Harvey House founder, had married Betty Drage when she was sixteen and he twenty-six. They both died in a plane crash in 1936, and Lucy sued for her daughter's half of his fortune, based on her contention that Betty had died first in the accident. The suit was settled for about $100,000.

This year, the living room of Lucy's modest home was where her old friend Woollcott settled in, rotund, bespectacled and wearing a polka-dot dressing gown, for a visit on his journey west to the coast to star in a theatrical production. "I open in Santa Barbara in the play George S. Kaufman and Moss Hart wrote for me, *The Man Who Came to Dinner*," he told a reporter. "It is a great play and it gives me perhaps the greatest opening line in the history of the theater: 'I may vomit.'"

Then Woollcott changed out of his dressing gown and into a brown jacket and white bow tie. It was time for lunch, and he was being picked up by another Kansas City friend, Dr. Logan Clendening. "If they open up with a big offensive on the western front next spring none of us knows where we may be," Woollcott said, speaking of the European war. "I should like to see Hitler and everyone like him come to grief. I am exceedingly unneutral."

Dr. Clendening arrived at the front door to collect his lunch date. "I am at the head of the street," the doctor said. "This street is too narrow for me to turn around in."

"You should cut out sweets," said Woollcott.

# 1247 West Fifty-sixth Street

Dr. Logan Clendening dispensed free medical advice from his large home off Ward Parkway to the thousands who read his popular syndicated newspaper column, "Diet and Health."

# From Barbecue to Brimstone

The Clendening home, 1247 West Fifty-sixth Street.

"What's the use?" he told them, speaking of exercise and healthy eating. "By giving yourself infinite trouble you may prolong your life perhaps a fortnight. Why not enjoy things as you go along?"

A Kansas City native, raised on Quality Hill when it was one of the finer neighborhoods, the doctor counted among his lifelong friends the socialite-turned-designer Lucy Drage and several in the literary world, including writers Sinclair Lewis, H.L. Mencken, Ernest Hemingway and Alexander Woollcott.

He studied at the University of Michigan and abroad at the University of Edinburgh but earned his medical degree at the University of Kansas. In 1939, as a full professor there, he established the department of history and philosophy of medicine.

Dr. Clendening had a red face with a large mustache and a sharp tongue, and he loved good cigars, irreverent jokes and publicity. He might have described himself as he did victims of high blood pressure: people "who have lived well, who are a little, or more than a little, overweight, who enjoy the good things of life, including the good things of the table, who have lived a gay and happy life under high pressure."

# Kansas City 1940

A year earlier, when a WPA sewer crew had been creating a racket with a jackhammer near his home, the doctor became irritated and decided to make a statement about the make-work projects created by his neighbor Tom Pendergast. He stuck a carnation in his lapel, slipped on a pair of kid gloves and grabbed an axe. For trying to demolish the jackhammer, he got a fifty-dollar fine and a few hours behind bars in the Country Club police station.

His patients loved the honesty and humor in his writing. Besides the newspaper column, he was the author of three popular books for a general readership: *The Human Body*, *The Care and Feeding of Adults* and *Behind the Doctor*. He wrote in the study of his rambling home. The view from his desk was suggested in the final sentence of *The Human Body*: "When death comes you may be certain you will disappear like all the rest and that you will not be missed nearly as much as in your sanguine moments you have been inclined to suppose."

# 3847 Broadway

Like others along the Ward Parkway corridor, Dr. Logan Clendening's household was run by hired domestic help. The doctor employed an English butler, a Norwegian maid and a Swedish cook, all of whom were white and lived on premises.

Many other servants in the neighborhood were black and commuted from their own homes via the Brooklyn-Sunset streetcar line. The nearly twelve-mile line linked the east side's blue-collar bungalows to the opulent mansions of the Country Club District, working a hook-shaped route from Forty-fourth and Brooklyn to Sixtieth and Ward Parkway, via downtown.

On Broadway, as Brooklyn-Sunset cars passed Thirty-ninth Street, passengers could watch for their reflections in the window of Tobler's Flowers. One block east was the home of Charles Hightower, an oiler for the Missouri Pacific Railroad. He and his wife, Eula, had one daughter, Rosella, a ballerina with the renowned Ballet Russe de Monte Carlo. (She came home for Christmas this year with a new friend, fellow dancer Freddie Franklin.)

Rosella's longtime instructor, Dorothy Perkins, also lived nearby, and her dance studio was a few blocks north in the Uptown Theater building. The neighborhood was home to teachers, salesmen, printers, night watchmen,

# From Barbecue to Brimstone

Tobler's Flowers, 3847 Broadway.

bookkeepers, nurses and custodians. Probably most had ridden a Brooklyn-Sunset streetcar.

This year, a group of neighborhood businessmen asked the Kansas City Public Service Company to remove streetcar tracks from Broadway between Linwood and Westport Road and to bring in bus service. The consensus among such men was that streetcars were a hindrance to automobile traffic—and thus to business. And Broadway was being considered for the route of a new Southwest Trafficway. "It's a crime even to think of having streetcar tracks on a trafficway," one commercial realtor told a Real Estate Board committee.

Powell Groner, the KCPS president, said that the removal of tracks along Broadway had been planned for years but had to wait for financing. Groner had led the company since 1927 and once had offered his assurance that "not in my lifetime do I expect to see streetcars eliminated in Kansas City."

Kansas City had grown up along its streetcar tracks. Now it was growing beyond them, beyond the city limits. The transit system crossed the state line and comprised more than five hundred miles of track and bus routes, about the same as cities with twice the population. There were 218 motor buses, 78 electric

# Kansas City 1940

trolley buses and 414 streetcars. Track mileage had shrunk as streetcars were replaced with buses, both electric and motorized.

This year, forty new trolley buses replaced streetcars on Fifteenth Street and on Prospect Avenue, part of an effort to make Prospect a trafficway. They joined thirty-four trolley buses on the former Northeast and Independence Avenue streetcar lines.

There was talk of removing tracks from Grand Avenue downtown and from Thirty-first Street. Because Twenty-seventh was seen as vital to a new Southeast trafficway, Groner promised that tracks there would be ripped up and buses would roll in.

One of the passengers looking for his reflection in Tobler's window could have been Everett Washington. He was forty years old, had a fifth-grade education and lived near Twenty-fourth and Woodland. He and his wife, Viola, had four children. Some of his neighbors rode the streetcar to jobs as yardmen, maids, janitors and garbage collectors. Washington worked in a private home off Ward Parkway, near the end of the Brooklyn-Sunset line. He was Powell Groner's chauffeur.

## 1323 Jackson Avenue

No sign announced that the two-story house on Jackson Street was the V.J. Williams Training School for Maids, Cooks and Housemen, established in 1908. For more than thirty years, young people had been coming to Viola Williams to learn the art and science of domestic work. She was seventy-two and widowed since 1917; with her thirty-nine-year-old daughter, Edith, she ran the school here in their home.

Public schools taught household skills, but some of these students were dropouts. The Williams school added a sense of respectability and racial pride to a curriculum of clean kitchens, spotless bathrooms, neatly folded laundry, skillful mending, home cooking and serving. Graduates could expect to earn as much as two dollars per day.

Cleaning, cooking, serving and doing other forms of domestic work for white people were common jobs among residents on this side of town. Many men worked as janitors, a job that could include living space for the family, although often it would be the least desirable unit in the basement of an apartment building. There was also a school for janitors in town, with training in sanitation, heating systems and construction, as well as race relations.

## From Barbecue to Brimstone

The V.J. Williams Training School for Maids, Cooks and Housemen, 1323 Jackson Avenue.

As many as 2 million American households employed domestic servants. The most elaborate upper-class homes might have had a number of specialists—companions, private secretaries, butlers, valets, footmen, tutors, chauffeurs, cooks, waitresses, housekeepers, yardmen, nurses, kitchen maids, parlor maids, ladies' maids or housemaids. The bare minimum for a large, wealthy household (according to Emily Post's 1940 edition of *Etiquette*) would be a cook, a butler and a housemaid. That was the exact configuration of the domestic staff at the J.C. Nichols estate in the Country Club District. All of his servants were white.

Times still were hard, but there was a stigma attached to service jobs for those who considered the work degrading or beneath them. They sought jobs in offices or retail stores, jobs that didn't include—as many domestic jobs did—room, board and a wardrobe of work clothes.

Most domestic workers served modest households, and most of those employed a single maid who cleaned, cooked and waited on table sixty hours per week, with Thursdays off.

Down at the Women's City Club this year, the head of the Garland School for Homemaking in Boston advised members how to deal with "the servant problem"—the problem of finding a good maid, keeping a good maid or

getting a maid to work efficiently. She said that it was largely a matter of knowing what kind of maid you needed. "A woman should consider the tempo of her home in hiring a maid," she noted. "If you are a rapid-fire, high-strung woman, no plodding maid will satisfy you. If your home is serene and of even tempo, hire an even-tempered, slow worker."

At Viola Williams's school on Jackson, there was no instruction on how to be a plodding maid. The students learned how to be modest, thrifty and hardworking employees. Probably they took no notice of the Women's City Club or, for that matter, the WPA training school for household employees, which offered a three-month session of classes.

To qualify for the WPA school, women had to be eighteen years old, free to accept employment when the course ended and white.

## 4524 Mill Creek Parkway

The cook who worked for the William Butler family achieved a bit of published notoriety this year. Butler, an insurance man, lived here in an apartment overlooking Mill Creek Park with his wife, Clara, and seventeen-year-old son, William III. The elder Butler was one of the top salesmen for the Business Men's Assurance Company, and the family lived well.

From some shared past experience—perhaps their world war military service—he was a friend of Cornelius Vanderbilt Jr., who years earlier had broken with his famous, wealthy New York family and made a name for himself as a writer, lecturer and world traveler.

Vanderbilt liked to boast that he had crossed the Pacific Ocean nearly fifty times and the Atlantic more than one hundred. He owned a thirty-thousand-acre dude ranch in Nevada but was rarely there. This year, he was on a national lecture tour, talking about America's inevitable entry into the European war. He made his Kansas City presentation in February.

Vanderbilt's extensive travels informed his lectures. He had interviewed world leaders, including Stalin, Gandhi, Chiang Kai-shek, Neville Chamberlain, Mussolini and Hitler. Six years earlier, his film *Hitler's Reign of Terror* documented the rise of the Nazis in Germany.

He didn't call it a lecture tour. Rather, he said that he was on a one-man crusade to warn people about subversive elements within this country—discontent and disagreements among citizens were the greatest danger. He said that war would be unavoidable and America would enter

## From Barbecue to Brimstone

The Butler home, 4524 Mill Creek Parkway.

it within two years. "It is a struggle between Christianity and the forces of chaos," he said, "with better than a fifty-fifty chance on the side of the powers of chaos."

He began his Kansas City talk as he began in each city—by slipping a gas mask over his face and announcing, "This, ladies and gentlemen, is God's image and likeness in Europe today. Aren't we mighty lucky we live in America?"

In spring, a written account of his time in Kansas City appeared in *Script*, a West Coast magazine for which he wrote a regular column. He mentioned his stay at the Hotel Muehlebach, his speech before a group of teachers at Municipal Auditorium, his visit with the *Star*'s editor, Roy Roberts, and his appearance at the Junior League's ice follies at the Pla-Mor Ballroom. And he made room for old friends:

> Dined with the Butlers and Bill Jr., which made me feel very old. Had no idea he could be seventeen years old. The Butlers have three unique things—one, the most delightful apartment I've seen in Kansas City. Second, a frisky, personality-plus dog who reminds me of the dog in The Thin Man. Third, an excellent Negro cook.

# Kansas City 1940

# 3142 Main Street

Here at the Pla-Mor in the steamy dog days of summer, thoughts might have drifted back to January and the sounds of steel blades cutting ice: the Greyhounds of the American Hockey Association, players with names like Shrimp McPherson and Hickey Nicholson celebrating the twelfth anniversary of hockey in Kansas City. Or perhaps the memory would be of February's *Sun Valley Snow Follies*, performed on synthetic ice in the ballroom, with J.C. Nichols Jr. dressed as a penguin and Cornelius Vanderbilt Jr. presenting a prize to the Junior Leaguer who sold the most tickets.

But the Pla-Mor had year-round charms. For entertainment, it was nearly all things to all people. They came here to shoot pool, eat a hamburger and bowl in the thirty-four-lane alley. They came for the dancing, the roller-skating, the swimming in summer and the ice skating in winter. They came to see the circus, the ice follies, the boxing match and the basketball game. They threw their group's party here, as the machine Democrats did before being trounced in the citywide April election.

The Pla-Mor was actually three structures: the Main Street building, with pool tables and bowling alleys on one level and a cavernous ballroom on another; a smaller building across Thirty-first Terrace where roller skaters

The Pla-Mor, 3142 Main Street.

whirled around a raised wood floor; and a larger building with a lobby entrance on Wyandotte, home to a 6,500-seat arena with a swimming pool for summer and an ice rink in winter.

Of course, dancing was king in what they called the "million dollar ballroom," with its two-story ceiling, chandeliers and high, arched windows. The dances were popular, and for fifty cents, you (the white customer) got to hear some of the best touring big bands in the country.

Sometimes the music came from the arena out back. In the spring, there was a Walkathon Speed Derby. Cash prizes were at stake as contestants walked in a circle as long as possible without falling down, competing in subcategories like Most Popular and Fastest Sprinter. While watching them trudge until they dropped, spectators could enjoy the Jay McShann Orchestra—with Charlie Parker—providing the soundtrack.

## Seventy-fifth Street and Prospect Avenue

After Prospect streetcars were replaced this year with trolley buses, Fairyland Park was said to be twenty to twenty-five minutes closer to downtown. You were that much closer to summer's music at the open-air Dance Pavilion, be it Jay McShann's orchestra; the "King of Hi De Ho," Cab Calloway (with Dizzy Gillespie on trumpet); the old Reno Club's favorite son, Count Basie, on tour after finding fame in New York; or some other big name band.

Nearby, the Skyrocket launched skyward several times a night all summer long. The wooden roller coaster was just one of many attractions (like the Pla-Mor, for whites only) at Fairyland, including the Skooter, the Shooting Gallery, the Ferris wheel, the Crystal Pool and Funland. You could roller-skate, swim or picnic on the grass. Some folks came just to dance under the stars.

Majel Horton, age eleven, lived with her parents in a house across Prospect from Fairyland. With her bedroom window open to a warm evening breeze, perhaps she could hear the continuous rumble of the Skyrocket, or Cab Calloway doing "Minnie the Moocher." After one September evening, she was less interested in the Skyrocket than in the sky itself. And she was not alone.

The heavens had been attracting attention all year. In late winter, the planets fell into a rare alignment—Mercury, Jupiter, Venus, Saturn and Mars—appearing as a diagonal string of nightlights, visible to the naked eye. At the time, someone noted that his ancestors would have seen this and begun preparing for the end of the world. A month later, sunspots scrambled

# Kansas City 1940

Fairyland Park, Seventy-fifth Street and Prospect Avenue.

radio communications in what was being called one of the worst electrical disturbances ever to hit the earth. In May, there was a (less rare) blue moon.

One night just before the autumnal equinox, the switchboard at the *Star* lit up with telephone calls about something seen from front porches in the hazy, blue dusk. Calls came from up to one hundred miles—from Higginsville, Missouri, to Lawrence, Kansas.

Most told of a very bright light that careened across the sky from east to west. Many described something so bright it threw shadows. Some heard a swishing sound and saw a long trail of sparks. Others reported an explosion or a distinct odor, red flares or greenish-blue flames. One man insisted that it was a Nazi bomber going down in flames, presumably having been chased by a British fighter plane six thousand miles across the Atlantic Ocean and half the North American continent.

A professor at the University of Kansas observatory who neither saw nor heard any such thing said that the descriptions would suggest a meteor. A meteor seen here, he said, would not hit the earth until it was hundreds of miles away.

Nevertheless, the next day, young Majel Horton found something in her yard across the street from Fairyland Park. It was a strange-looking rock, pocked and

porous like a clinker brick. She and her father believed that it might be a rock from space. They took it to an expert, Dr. Sidney Ekblaw, at the University of Kansas City. Professor Ekblaw opened his penknife and poked around the holes of the odd stone. He scraped out a few old spider eggs. A meteor, he told Majel and her father, probably would not contain any spider eggs.

## 5906 Grand Avenue

Ross Sheldon knew that the world was shrinking. He might have been a farm boy from Missouri, but he was also a college student, finishing his junior year at the University of Kansas City. No college student could fail to see how Hitler had been stealing pieces of Europe since the previous September and appeared to want whole chunks of the globe.

Ross had a room at this address, working as a houseman for the older couple who owned the house. It was convenient to school, just a streetcar ride and a short walk or a ten-minute bicycle ride. On campus, there was plenty of talk about war, how the United States could not avoid it. Perhaps it seemed that one should grab opportunities while one could.

Ross Sheldon's home, 5906 Grand Avenue.

# Kansas City 1940

Because of the war, it was the summer to "See America," as travel agencies said, selling tours to Yellowstone, New England, the world's fairs in New York and San Francisco. There was Canada, which promised "a friendly foreign atmosphere," and Mexico was promoting itself as "a faraway land near by."

Ross made about fifteen dollars per month. A week at the New York fair would set you back $59.90. A weeklong "economy trip" through the Rockies cost $73.88. A week didn't seem like nearly enough time for a twenty-one-year-old college student on what could be his last summer adventure.

Like Canada, Mexico required no passport, just a tourist card and a quick customs check at the border. Ross and his buddy Willis, another rural Missourian, pooled their money, $100, and packed a few blankets, a hatchet, cooking kits, canteens, a first-aid kit, a few clothes, toilet articles and, because they didn't speak the language, a Spanish dictionary. In early June, they left town for Mexico City, pedaling their bicycles.

When they rode back to campus one August afternoon, fifty-five days and 3,500 miles after leaving, Ross and Willis were bronzed, dirty and tired but happy.

"Haven't had a shave since leaving Dallas six days ago," said Ross, fanning his suntanned face with a straw hat. "And the last bath we had was in the Gulf of Mexico."

Mexicans had treated them well, they said, feeding them, giving them beds and refusing payment. Willis conquered the language problem by sketching picture messages. In Mexico City, they were caught up in election day rioting, and Ross took a spent bullet in the back but was unhurt. One day, with no food or water, they pedaled one hundred miles across the Mexican desert. The hundred dollars was spent, much of it on tourist cabins on the ride down, when it rained most every night. "Yeah, we came up from Dallas on fifteen cents and three boxes of oatmeal," said Willis. "I'm prepared to write an oatmeal testimonial; it's an all-purpose food."

Part of the journey they kept to themselves—twenty-one-year-olds on their own in Mexico. They leaned against their bikes: single-speeds, coaster brakes, balloon tires, fenders, headlights, kick stands, wide saddle seats and metal baskets piled with gear. "If we had it to do again, we'd leave the dictionary at home and take four more canteens," said Ross. "You get mighty thirsty pumping a bike over deserts and mountains."

### From Barbecue to Brimstone

## 7336 Grand Avenue

The Robert J. Hoyland family lived in this Tudor bungalow on a block of similar bungalows in a white-collar, middle-class neighborhood near the southern city limits. It was the kind of neighborhood where you could have awakened one morning and strolled outside in your bathrobe, in the words of one *Star* reporter, "to the cry of birds and the heavy aroma of flowers and greenery, ineffably peaceful, and then in the morning paper off the lawn read that Paris has fallen."

Bob was the assistant financial editor at the *Star*, and his wife, Louise, worked as an executive secretary at a telephone company. They had a five-year-old son, Terry, and Louise was expecting a baby in July. As news reports described a red-and-black swastika flying from the Eiffel Tower, a cablegram arrived from friends in London: "Can you care for our daughter?"

Since September 1939, when Nazi tanks rolled into Poland and commenced the European war, Britain had been evacuating civilians, primarily children, from cities considered priorities of German bombers. Most had been relocated to the countryside, to any available private housing or to newly built government camps. Commonwealth countries—Canada, Australia, New Zealand and South Africa—had offered to take some, as

The Hoyland home, 7336 Grand Avenue.

had the United States. Some Brits who could afford it arranged for private relocations, in hotels or with friends or family overseas.

And so they sailed from Southampton to New York City, boarding trains there for scattered destinations across America. Kansas City became a temporary home for some of the refugees—the thin fifteen-year-old boy with the horn-rim glasses, carrying a golf bag and a suitcase with a "Waterloo" decal, insisting that he was not a refugee but rather an "evacuee." And the thirteen-year-old Jewish youth, veteran of many a London air raid, who said, "The whistling bombs are rather bad. And we haven't slept very well for the last few weeks."

Reginald and Vera Vince had first met Bob and Louise Hoyland ten years earlier on an extended visit to Kansas City—Vince worked in the London office of Louise Hoyland's employer—and the couples became friends. They were already separated from their six-year-old daughter, Ann, who had been evacuated from their London home, but the Vinces preferred that she be even farther out of harm's way, if possible, in the care of friends in America.

The Hoylands cabled their eager response: "She will be a fine playmate for Terry." Later, they all went down to meet young Ann Vince at Union Station and brought her to her new home. She enrolled at the nearby J.C. Nichols School with Terry and made good friends of the other little neighborhood girls. And perhaps the English-style façades of all those bungalows reminded her of home.

## 301 Van Brunt Boulevard

Church pastors knew a chance to deliver a gut-grabbing sermon when they saw one. And that summer, the war in Europe, especially after Nazis marched through Paris and began blitzing London, provided plenty of grist for fire and brimstone.

The faithful had gathered here at Northeast Presbyterian for a union service—the huge crowd included members of the Independence Boulevard Christian Church—and they were ready for the awful truth. Dr. Harry L. Ice, pastor of the Independence Boulevard congregation, was here to tell them about the sorry state of the world. Immorality was to blame for the fall of France, as it had been in the Roman empire, said Dr. Ice. He warned that "when a nation's moral fiber snaps, the nation crumbles."

# From Barbecue to Brimstone

Northeast Presbyterian Church, 301 Van Brunt Boulevard.

If the titles of Kansas City church sermons that summer suggested anything, it was that war was provoking questions in churches all over town, as in "What on Earth is God Doing?" "Does Anything Matter?" and "Has Christianity Failed?" Others seemed to be about taking action: "Casting Out Fear"; "What America Needs Now"; "The War, Religion and the Future"; and "What Can We Do About It?—America's Responsibility in a Warring World."

The Kansas City Council of Churches issued a statement aimed at Europe's tyrants:

> *Any great leader is significant only when he loses himself in the good of the common people. Today we have a revival of this glorification of the superman. He struts across our daily papers and our newsreels. The implication is that he alone is important. The real greatness of a nation will finally be measured, not by its superman or its mechanized war equipment, but by the character and initiative of its people.*

Meanwhile, many pastors appeared to be following the example set by Dr. Ice, stepping around the issue of America entering the war and instead

making the most of an opportunity to update their timeless message: morals were in decay, individualism was rampant and it was time to repent or face eternal damnation. "How much America is troubled by these same questions is evident to even the superficial observer," Dr. Ice said at Northeast Presbyterian. "Militarism is in the saddle, the American home is breaking down, profit is the biggest thing in our world and churches throughout the land are complaining about the lack of attendance and the superficiality of the faith of many. America, why don't you think?"

CHAPTER 6
# Back Home

## 203 East Sixty-eighth Street

Home for the Frank Griffin family was the corner of Sixty-eighth and Grand in the Armour Hills subdivision of the Country Club District. It was a white, middle-class neighborhood where the fathers were salesmen and business executives, the mothers were housewives and some households included lodgers and live-in maids.

The Griffins were like others in that Frank and his wife, Fanny, were high school graduates with children—son Curtis and daughter Jean—attending college. Their older sister, Dorothy, worked in a hosiery shop.

Curtis (friends called him Curt) had turned twenty near the end of his sophomore year at the University of Kansas City. He was slender, just under six feet tall and handsome, with thick, dark hair. His girlfriend was Mary Jane Kernodle, curly-haired with a heart-shaped face and wide-set eyes. She also attended KCU. Curt and Mary Jane had been classmates at Southwest High School, where the class of 1937 yearbook listed her as "school banker, member of production staff of *The Rivals*, president of her home room, member of Powwow Club." His credits were fewer: "Member of crack platoon in the R.O.T.C two years."

After Paris fell and while bombs were devastating London, it felt as if war was getting closer. Opinions here remained mixed about Americans fighting another European war. Colonel Lindbergh and his America Firsters had followers, but not everyone believed that isolation was the answer.

## Kansas City 1940

The Griffin home, 203 East Sixty-eighth Street.

In a letter to the *Star*, a mother of a teenage daughter and a twenty-three-year-old son made clear her view:

> *I am sure America can whip any or all nations that try to come over here. My heart aches for every mother who has a son in that awful war, but it isn't our war. If the time ever comes we will fight our own battles under the Stars and Stripes in the good old U.S.A.*

Two weeks later, a punch-press operator with two daughters and no sons at home seemingly answered her with his own letter:

> *Remember this, you modern mothers of sons, so long as the Stars and Stripes flies, so long as there is man on earth we of America will have to sacrifice our sons and fathers and brothers on the field of battle or succumb to the tyranny and brutality of lust and greed. And so long as this fact remains we must and will have to rear our boys to be soldiers, like it or not. Mothers should stop this talk of what their boys mean to them, and start teaching them they have responsibilities and loyalties to those who died for them.*

# Back Home

Here my tour of 1940 Kansas City brings me home again. It's a twenty-first-century summer evening. Cicadas are serenading the twilight. I'm relaxing on my screened porch with a beer, looking across the street at the house where Curtis Griffin grew up and where he sometimes imagined his future.

Perhaps in the summer of 1940, sitting on the screened porch of that house with the day's heat fading and cicadas singing, Curt Griffin read those letters in the newspaper. He probably would have agreed with one of them. By that September, when President Roosevelt signed the Selective Service Training Act establishing a draft for compulsory military service, those two years of ROTC probably seemed more important than they did in the high school yearbook. Past and future were swirling together.

# Epilogue

First Lieutenant Curtis Griffin ("Griff" to his crewmates) was killed in action over Naples, Italy, on July 17, 1943, while flying his twenty-fifth bombing mission as pilot of a B-24 Liberator. A crewmate who parachuted from the crippled bomber later wrote to his widow:

> *The last I saw of your husband, he was desperately fighting the practically uncontrollable, and burning, shell-torn plane…apparently mortally wounded…yet calm and cool and methodical as though he were pressing the front door bell. He was pressing the emergency alarm bell, the signal to abandon ship, and calling the crew over the interphone, repeating "Bail out…I'll hold her as best I can…bail out."*

The future brought Curt Griffin an Air Medal with three Oak Leaf clusters, a Distinguished Flying Cross, a Purple Heart and a war hero's eulogy at age twenty-three.

---

World War II ended many futures, delayed some and changed others.

Kansas City had to put off plans for new trafficways. In 1944, Congress passed a Federal Aid Highway Act, which called for a "National System of Interstate Highways" that could move soldiers, equipment and materials more efficiently in the event of another war.

# Epilogue

Funding became available for the Southwest Trafficway, which opened in November 1950. The *Star* called it "a monumental thing, a structure of the new traffic age." It was the first new expressway of several eventually absorbed by I-35 and I-70. At the ribbon-cutting ceremony, Barney Allis, then vice-chairman of the Downtown Committee, awarded government bonds to its first two motorists. They were suburbanites. One lived in Lee's Summit and the other in Shawnee.

In wartime, the North American Aviation bomber plant became one of the area's largest employers, even as it resisted hiring blacks as long as possible. Afterward, it became a General Motors factory, churning out Buicks, Oldsmobiles and Pontiacs. Other similar conversions solidified Kansas City as a town of industry, not just agriculture and livestock as it had been before 1940.

Journalists, including syndicated columnist Westbrook Pegler, had once compared Kansas City's sinful nightlife to that of Paris. During the war, Pegler wrote about the cleaned-up city, this time referring to its former self as "the Paris of the Western Plains." In 1950, the city's centennial inspired a *Holiday* magazine feature that recast it as the "Sodom-Gomorrah of the short grass":

> *Kansas City grew from a wild, noisy cow town into the second largest city in the Missouri Valley—a rowdy, prosperous city, noted for its meat, mills and sin. In the 1930s, under the political rule of an autocratic roughneck named Thomas J. Pendergast, the city became a rollicking haven of gangsters, gamblers, con men, striptease dancers, traveling salesmen, cattlemen and conventioneers. Clip joints, fleshpots and homicide flourished. In the burlesque shows even g-strings were superfluous. Votes were stolen by the handful and voting lists were padded with names taken from tombstones. Then Uncle Sam moved in and sent Pendergast to jail as a tax dodger. The machine fell apart and Pendergast died. Reform came.*

Roy Roberts, the *Star*'s editor, seemed to answer in his foreword to *City of the Future*, a self-congratulatory history written for the centennial by two of his reporters:

> *The period of boss rule and gangster sin was so colorful, so dramatic, writers invariably have turned to it as their conception of Kansas City. Yet that period was only a chapter…The progress of more than a decade as a city freed from political bondage has been almost ignored in the scores of*

# Epilogue

*magazine stories depicting Kansas City in a fashion its own citizenry does not recognize today, except as a memory.*

It was a memory reformers wanted to forget. Ironically, it's a memory beloved today by those who believe that it provides a sense of place and identity, not the least for its music. None other than John Cameron Swayze, in his liner notes for a 1958 Capitol Records jazz release, *KC in the '30s*, might have provided its best imagery when he tweaked an old nickname. "Westbrook Pegler called it the Paris of the Plains," he wrote.

---

The "World of Tomorrow," defined by General Motors' Futurama exhibit at the 1939–40 New York World's Fair, was billed as a 1960 preview. Many characters in this book did not live to see whether it became reality. Of those who did, none might have been happier than Barney Allis. In the '50s, the vacant lot across from Municipal Auditorium became an underground parking garage topped by a landscaped plaza that now bears his name. His dream of a local Futurama, with expressway traffic flowing downtown, was coming alive in new freeways and plans for a downtown loop. In 1962, Allis dropped dead of a heart attack at seventy-six on a sidewalk near the Hotel Muehlebach. He missed downtown's decline: freeways also flowed outward, toward far-flung suburbs.

Robert Richardson, the candyman whose subway "pipe dream" was considered fanciful compared to Futurama, also died in 1962 at eighty-two. He had written two books, a collection of poems titled *Pipe Dreams* and prose (*Parking Lot*) about the square of asphalt next to his candy store.

Former mayor John Gage lived to be eighty-two, when he was hit by a truck near his downtown law office and later died from injuries. He had served three terms as mayor and was remembered by his city manager, L.P. Cookingham, as "one of the most dedicated men I have known. He was for honesty and integrity and he insisted on it at City Hall."

Cookingham, who served for nineteen years, lived to be ninety-five. He oversaw growth of the expressway system; construction of public housing, Starlight Theater and the international airport; annexation of Kansas City North; and acquisition of baseball's Athletics. A story was told about him hiring some of city hall's first black workers, which brought white protests. He responded, "Those aren't black people; those are City Hall employees."

# Epilogue

Lucile Bluford died at ninety-one, having worked at the *Call* for more than seventy years. Her failed discrimination suit against the University of Missouri led to a new journalism program at Lincoln University in Jefferson City. Years later, MU gave her an award for distinguished service. "She fought bigotry in her personal life, and then she forced Missouri to face it," said former mayor Emanuel Cleaver.

Sol Stibel, former owner of perhaps the city's most famous jazz spot, the Reno Club, returned to barbering after the crackdown closed the club; he lived to be eighty. His obituary in the *Star* mentioned that he "previously operated a tavern here."

Milton Morris moved Milton's Tap Room from Troost to Main in the 1950s (his extensive record collection took the place of live jazz), ran for Missouri governor a few times and paid for a running newspaper ad declaring, "I ain't mad at nobody!" Most nights, he sat at his bar with a cigar and a scotch and water and told stories about the old days. He died at seventy-one.

Jud Putsch learned to love the restaurant business. When he closed the Blue Bird Cafeteria in the late 1940s, he opened a fine dining place on the Country Club Plaza, Putsch's 210. "It wasn't designed for people interested in hamburgers fried in the window, malted milks and beer," he said. A Plaza cafeteria followed, then a coffee shop and a sidewalk café and then more area cafeterias. He lived to be eighty-two.

Cornelius Vanderbilt Jr. died at seventy-six. He married seven times. His third wife, Helen, remarried after their 1940 divorce. Her new husband was Kansas Citian Jack Frye, founder of Trans World Airlines.

When former grocer Abe Trillin died at sixty, he had been a literary restaurateur for years. (He published his poems on the menu, as in "Don't sigh / eat pie.") His son, Buddy, known widely by his given name, Calvin, also became a writer and paid tribute to his dad in *Messages from My Father*.

Arthur Bryant carried the barbecue legacy of Henry Perry to world fame, aided by Calvin Trillin's book *American Fried*, in which he declared Bryant's "the single best restaurant in the world." Bryant died at eighty.

At this writing, Mickey Rooney lives on at ninety-three. At seventy-three, he gave an interview to the *New York Times*. "You know, for three years I was the top star of the world," he said. "I've had my day at bat. I have no delusions of grandeur. I'm happy with everything that's been given to me. So you could just say I'm a man of opposites. I'm satisfactorily dissatisfied. A loud quiet man. A very happy sad man."

Elroy Peace Jr., the tap-dancing phenom who auditioned for Bojangles and won a jitterbug contest at a Monarchs game, joined the traveling act of

# Epilogue

former vaudevillian Ted ("Is everybody happy?") Lewis. One role was in the tune "Me and My Shadow," in which Peace would mimic Lewis's soft-shoe as his "shadow." Perhaps still living in Los Angeles, he would be eighty-four.

Jay McShann, who outlived his meteoric, drug-addicted saxman Charlie Parker by half a century, became a jazz legend and toured the world, keeping his home in Kansas City.

Ann Vince, the young British girl who found refuge here from Nazi bombs, moved after a year to live with other friends in Chicago and then returned to London. Years later, her Kansas City housemate Janet Hoyland visited and found her to be "a very attractive, slim brunette woman in her mid twenties" and "charming, warm and shyly reserved." They exchanged Christmas cards for years until Janet's began coming back with no forwarding address.

Thomas Hart Benton died in his studio in 1975 while putting the finishing touches on a mural, *The Sources of Country Music*. He was eighty-five. "You can't retire from life," he had once said of painting. "It is life to me. What the hell else would I do?"

Phil Rizzuto, who died at eighty-nine, became an MVP, Hall of Fame shortstop for the Yankees and had a forty-year career as their broadcaster, with a trademark phrase: "Holy cow!" Satchel Paige went on to the major leagues, finished his career at age fifty-nine with three innings for the Kansas City Athletics and died at seventy-five. His teammate Buck O'Neil managed the Monarchs before they folded in the 1950s, enjoyed late-life adoration as a spokesman for Negro League history and lived to be ninety-four.

Newsmen Swayze and Walter Cronkite moved on to national fame, Cronkite as the acknowledged "most trusted man in America" and Swayze, after a stint as an NBC anchor, as a Timex pitchman ("Takes a licking. Keeps on ticking."). Cronkite and his wife are interred at a Kansas City cemetery.

Police Chief Lear B. Reed left that post in 1941, served in World War II and subsequently worked as an auditor for Montgomery Ward, as the managing editor of a California newspaper and as a State Department employee. He died at seventy-two. Contrary to his 1940 "viceless town" declaration, Kansas City continued its association with organized crime for several years.

Powell Groner, the man who ran the Kansas City Public Service Company for thirty years, died at eighty-four. The *Star* summed up his career by noting that "he was dealing with forces beyond his control or the control of any individual" and that the demise of streetcars "was one of those enormous social forces that alters civilizations."

Early in his KCPS years, Groner said, "Even if every person had a motor car, there wouldn't be room to use them. So the streetcar will stay." In 1956,

# Epilogue

the year before he left office and streetcars left town, he spoke to a group of civic leaders. He told them that downtown would not remain the city's vital center unless it had more people and fewer automobiles. "How are we going to correct this situation, thereby restoring our cities as great metropolitan centers rather than have them degenerate into sprawling country towns?" he said. "If there be courage and vision, capital will flow in as it always does to a progressive and live-wire community."

Will Hamilton, my great-grandfather, worked until age seventy-five. In retirement, he enjoyed listening to baseball games on the radio, eating gooseberry pie at Putsch's Cafeteria and checking prices of canned goods in supermarkets. He died when he was ninety-one and I was thirteen. I still miss him.

# Suggested Reading

*My sources were many and varied, but here are a few I found particularly helpful on Kansas City topics. For time traveling, review old issues of the* Kansas City Star *and* Times, *the* Kansas City Journal *and the* Kansas City Call.

Conrad, Edward A. *Kansas City Streetcars: From Hayburners to Streamliners.* Blue Springs, MO: Heartland Rails, 2011. For the Kansas City Public Service Company streetcar era.

Coulter, Charles. *"Take Up the Black Man's Burden": Kansas City's African American Communities, 1865–1939.* Columbia: University of Missouri, 2006. For an overview of local black culture.

Driggs, Frank, and Chuck Haddix. *Kansas City Jazz: From Ragtime to Bebop—A History.* New York: Oxford University, 2005. For a thorough treatment of early local music.

Haskell, Henry C., and Richard B. Fowler. *City of the Future: A Narrative History of Kansas City, 1850–1950.* Kansas City, MO: Frank Glenn, 1950. For a midcentury perspective.

Larsen, Lawrence H., and Nancy J. Hulston. *Pendergast!* Columbia: University of Missouri, 1997. For the story of Thomas J. Pendergast and his political machine.

## Suggested Reading

Sixteenth Census of the United States, 1940. http://1940census.archives.gov. For details on neighborhoods and individual lives.

Trillin, Calvin. *Messages from My Father*. New York: Farrar, Straus, Giroux, 1996. For personal memories of his family and hometown.

# Index

## A

air travel and aviation  12, 33, 64, 143, 144
Allis, Barney  88, 142, 143
American Royal  97, 99
Anderson, Marian  34, 45
automobiles and driving  26, 59, 83

## B

Baltimore Building, 1016  78
barbecue  105, 144
Barclay Apartments  109
Basie, Count  29, 68, 129
Benton, Rita  95
Benton, Thomas Hart  77, 93, 94, 145
Big 4 Employment Agency  43
*Bill Bruno's Bulletin*  52
Blue Bird Cafeteria  24, 105, 107, 144
Bluford, John  62
Bluford, Lucile  62, 144
Boulevard Manor apartment hotel  65
Bryant, Arthur  107, 144
Bryant, Charlie  107

## C

Carrillo, Leo  98
Century Room  66
churches and sermons  33, 64, 75, 111, 134
City Food Stores  70
city hall  11, 12, 21, 22, 23, 64, 65, 73, 86, 143
City Market  70, 72, 74
Clendening, Logan  20, 120, 122
Community Church  75
construction projects  12, 40, 74
Cookingham, L.P.  24, 108, 143
Country Club District  16, 69, 112, 122, 125, 137
Country Club Plaza  33, 68, 74, 117, 119, 144
Cowboy Inn  96
Cronkite, Betsy  80, 81, 145
Cronkite, Walter  81, 145

## D

dancers and dancing  12, 27, 54, 66, 69, 72, 75, 80, 88, 113, 122, 128, 144

# Index

demolition of old buildings  49, 74, 90, 108
Dewey, Thomas  61, 97
DiMaggio, Vince  115
dogs  39, 100, 127
Donnell, Forrest  60, 62
Down and Out Club  42
Downtown Committee  46, 47, 48, 49, 87, 88, 142
Drage, Lucy  119, 121
Dyer, Daniel B.  50

## E

elderly citizens  53, 55

## F

Fairyland Park  68, 129
Fountain View Apartments  113
Franklin, Chester  61, 63

## G

Gage, John B.  24, 73, 115, 118, 143
gandy dancers  43
Gardner, Paul  93
Gibraltar Building  51
Gilmore, Quincy J.  113
*Gone with the Wind*  55, 56
Grace and Holy Trinity Episcopal Cathedral  81
*Grapes of Wrath, The*  52, 94
Griffin, Curtis  137, 141
grocers and grocery stores  17, 68, 70, 73
Groner, Powell  108, 123, 145

## H

Hammond, John  29
Hannibal Bridge  31, 33
Harzfeld's  47
heat wave  35, 36, 37
Hemingway, Ernest  88, 90, 121
Hightower, Rosella  122
Hippodrome  49
Hitchcock, Billy  115

Holmes, Burton  45
horses and livestock  97, 99
Hotel Baltimore  50, 88
Hotel Muehlebach  61, 67, 88, 91, 127, 143
hotels, other  50, 60, 65, 67, 70, 87, 96, 108, 109
*Hot Mikado, The*  34, 45, 113
housing and neighborhoods  11, 16, 38, 41, 43, 55, 59, 62, 71, 74, 82, 85, 99, 100, 111, 113, 121, 122, 133, 137

## I

*Independent*  117, 119
Ivanhoe Temple  53

## J

Jenkins, Reverend Burris  75
Johnson, Pete  28
Jordan, Reverend Raymond  111

## K

Kansas City Art Institute  93, 94
Kansas City Blues  19, 62, 114, 117
Kansas City Board of Education  94, 118
*Kansas City Call*  56, 61, 62, 64, 112, 144
Kansas City Chamber of Commerce  31
Kansas City Council  22, 24, 47, 68, 108
Kansas City Greyhounds  128
*Kansas City Journal*  16, 22, 29, 77, 80, 82, 103, 109, 114, 116
Kansas City Monarchs  114, 116, 144, 145
Kansas City Museum  51, 93
Kansas City Police Department  25, 27, 44, 46, 50, 62, 84, 99
Kansas City Public Service Company  19, 49, 108, 123, 145
*Kansas City Star and Times*  12, 22, 31, 32, 34, 38, 42, 47, 56, 61, 62, 74, 79, 85, 86, 87, 90, 100, 102, 109, 127, 133, 138

# Index

Kansas City Stockyards 36, 92, 96, 97, 100, 110
Kansas Ciy Police Department 145
KCMO 79, 82, 103

## L

Landis, Kenesaw Mountain 118
Lang, Frank 74
Lazia, Johnny 101
Lee, Julia 66
Liberty Memorial 35, 40, 93
Lincoln High School 62
Lincoln Theater 56
Lindbergh, Colonel Charles A. 103, 137
Linwood Boulevard Christian Church 75
Locarno Apartments 116, 119
Lochman, Walt 115
Loew's Midland Theatre 55, 56
Long, Loula 99
Long, R.A., former home of 51, 93

## M

maids and domestic workers 15, 55, 110, 122, 124, 137
Mainstreet Theater 30
Mayerberg, Rabbi Samuel 24, 117
McClintock, Miller 48, 87
McElroy, Henry 23
McElroy, Mary 23
McShann, Jay 66, 129, 145
Milton's Tap Room 66, 115, 144
Morris, Milton 66, 144
motion pictures 56, 58, 93
Muehlebach Field 114
Municipal Auditorium 45, 49, 62, 64, 83, 87, 127
music and musicians 12, 19, 28, 36, 54, 65, 66, 69, 90, 102, 105, 110, 129, 143

## N

newspapers 16, 22, 29, 42, 52, 56, 62, 64, 76, 77, 79, 82, 90, 97, 102, 109, 112, 114, 116, 120, 138, 144

New York World's Fair 34, 45, 58, 90, 113, 132, 143
Nichols, J.C. 16, 20, 64, 112, 119, 125
nightclubs and nightlife 27, 66, 69, 88, 96, 115
Northeast Presbyterian Church 134

## O

O'Neil, Buck 115, 145

## P

Paige, Satchel 115, 145
Parade Park 35, 36, 62
"Paris of the Plains" 143
Parker, Charlie 29, 66, 106, 129, 145
parking and parking lots 31, 46, 49, 51, 66, 71, 74, 75, 86, 87, 108, 143
Peace, Elroy, Jr. 114, 116, 144
Pegler, Westbrook 142, 143
Pendergast, Jim 22
Pendergast political machine 12, 22, 24, 25, 29, 30, 56, 79, 86, 101, 128, 142
Pendergast, Thomas J. 12, 19, 21, 94, 122, 142
Penn Valley Park 35, 36, 62
Penny Ice Fund 38
Perkins, Dorothy 122
Perry, Henry 106, 144
Petticoat Lane 47, 49, 69
Pla-Mor entertainment complex 49, 68, 127, 128
presidential election campaign 34, 56, 60, 63, 97, 118
Priddy, Jerry 115
public transportation 17, 19, 46, 48, 49, 70, 74, 84, 86, 87, 109, 118, 122, 129, 145
Putsch, Justus "Jud" 107, 108, 109, 144
Putsch, Nelle 107

## Q

Quintanilla, Luis 90, 91, 93

# INDEX

## R

racial discrimination  36, 43, 62, 64, 110, 111, 114, 115, 126, 129, 143
radio programs and stations  29, 79, 102, 115
Reed, Lear B.  25, 27, 46, 49, 84, 99, 145
Reid-Ward Motor Company  83
Reno Club  28, 129, 144
Republican Workers Club, Third Ward  60
restaurants  21, 33, 60, 74, 88, 103, 105, 107, 144
Rizzuto, Phil  115, 145
Roberts, Roy  127, 142
Robinson, Bill "Bojangles"  33, 45, 113, 114, 144
Rooney, Mickey  33, 57, 144
Roosevelt, Franklin D.  12, 15, 42, 44, 56, 58, 61, 62, 94, 97, 103, 112, 118, 139
Ruppert, Colonel Jacob  114
Ruppert Stadium  80, 114, 118

## S

Salvation Army  38
Sheffield Steel  37, 50
Smith, Hilton  115
smoke, problem of  30, 32, 105
South Central Business Association  24, 107, 111
Stauffer, Grant  31
Stearnes, Turkey  115
Stibel, Sol  29, 144
Stonewall Court Apartments  99
stores (downtown)  47
Sturm, Johnny  115
Swayze, John Cameron  19, 80, 143, 145
swimming pools  36, 62, 129
Swinney, Edward F.  117
Swope Park  35, 37, 62, 93

## T

tax reassessment, Jackson County  11, 12, 15
Taylor, Myra  67
telephoning  77
tent shows  52
Ten-Year Plan  23, 86
Time Service of Kansas City  77, 79
Tobler's Flowers  122
traffic and trafficways  24, 31, 40, 46, 48, 49, 84, 85, 86, 88, 107, 123, 124, 141, 143
Trillin, Abe  70, 72, 144
Trillin, Calvin  45, 144
True Vow Keepers Club  53
Truman, Harry  22
Trumbauer, Frankie  65
Turner, Big Joe  28

## U

unemployment relief  12, 39, 41, 44
Union Station  26, 33, 34, 58, 60, 93, 109, 118, 134
United Press  81, 82
University of Kansas City  90, 93, 131, 137
Uptown Theater  58, 122

## V

Vanderbilt, Cornelius, Jr.  45, 126, 128, 144
Vogue Theater  58

## W

war and reaction  25, 34, 36, 42, 46, 58, 61, 64, 70, 79, 91, 102, 120, 126, 130, 131, 133, 135, 137, 141, 145
WDAF  102, 103, 110
West Terrace pool  36
William Rockhill Nelson Gallery of Art and Atkins Museum  92, 119
Willkie, Wendell  34, 60, 61, 63, 97

# INDEX

Winstead's 74
Wolferman, Fred 69
Wolferman's grocery 47, 68, 70, 71
Woollcott, Alexander 119, 120, 121
Work Projects Administration 12, 15, 36, 37, 39, 41, 42, 55, 61, 72, 74, 85, 93, 100, 109, 122, 126
Wright, Frank Lloyd 33, 75, 94, 100

# About the Author

John Simonson is an independent writer and editor. His work has appeared in newspapers, magazines, corporate publications, museum exhibits and jazz recordings and on websites and beyond. His blog, "Paris of the Plains," became the basis for *Paris of the Plains: Kansas City from Doughboys to Expressways*, published in 2010 by The History Press. He lives in Kansas City, Missouri.

*Visit us at*
www.historypress.net

*This title is also available as an e-book*